NORTH CAROLINA
portrait of a state

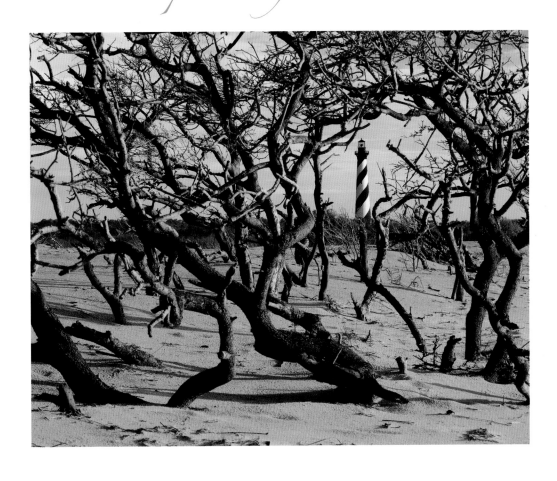

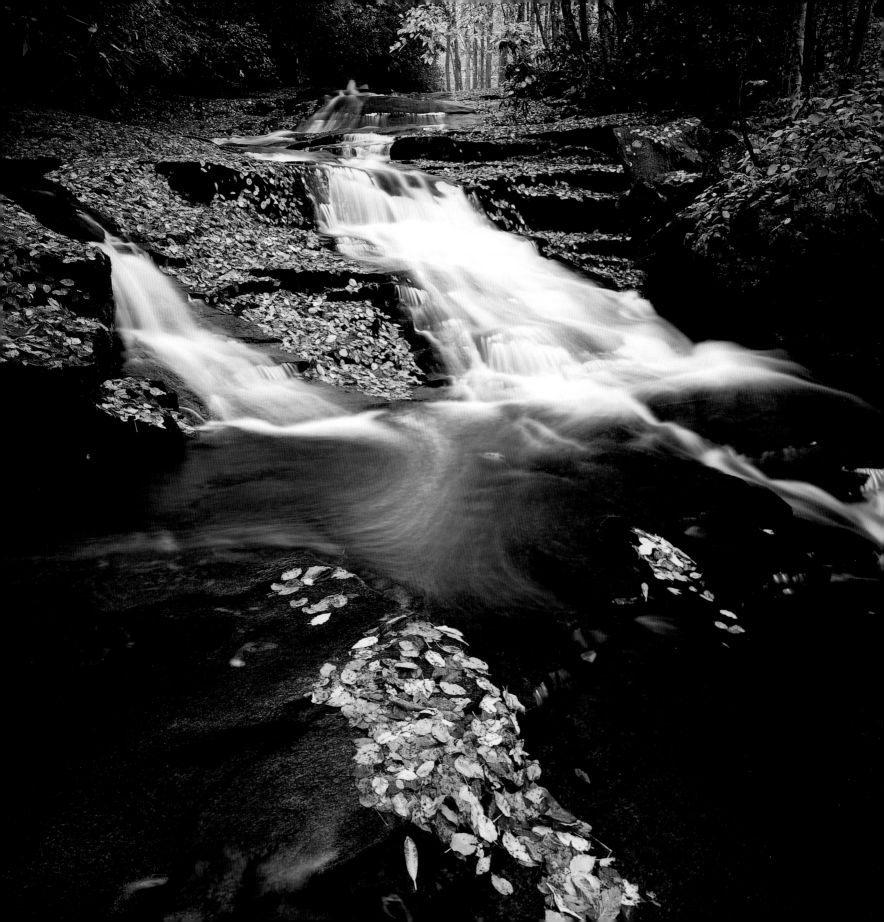

NORTH CAROLINA
portrait of a state

GEORGE HUMPHRIES

To George and Stella,
 Thank you for your kind hospitality to me during my year at UEA.
I will always appreciate it and am so glad to see you again.
 Lynn Marchbanks and family
 June 23, 2009

GRAPHIC ARTS BOOKS

Photographs © 2003 by George Humphries

Library of Congress Control Number: 2004103695
International Standard Book Number: 978-1-55868-836-0
Graphic Arts Books, an imprint of
Graphic Arts Center Publishing Company
P.O. Box 10306, Portland, Oregon 97296-0306
503/226-2402; www.gacpc.com

President: Charles M. Hopkins
Associate Publisher: Douglas A. Pfeiffer
Editorial Staff: Timothy W. Frew, Tricia Brown, Kathy Howard, Jean Bond-Slaughter
Production Staff: Richard L. Owsiany, Heather Doornink
Cover Design: Elizabeth Watson
Interior Design: Jean Andrews

Printed in China
Third Printing

◄ ◄ The Cape Hatteras Lighthouse, North America's tallest at 208 feet and
a National Historic Landmark, was moved almost half a mile in 1999.
◄ Pisgah National Forest is especially known for its creeks and waterfalls,
including Looking Glass Creek and Falls.

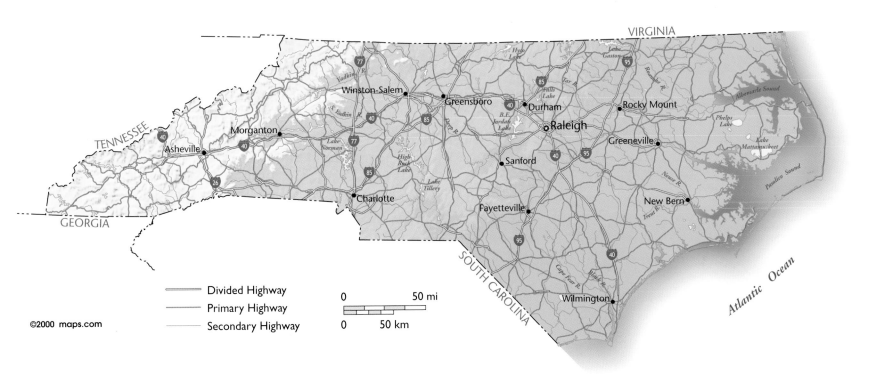

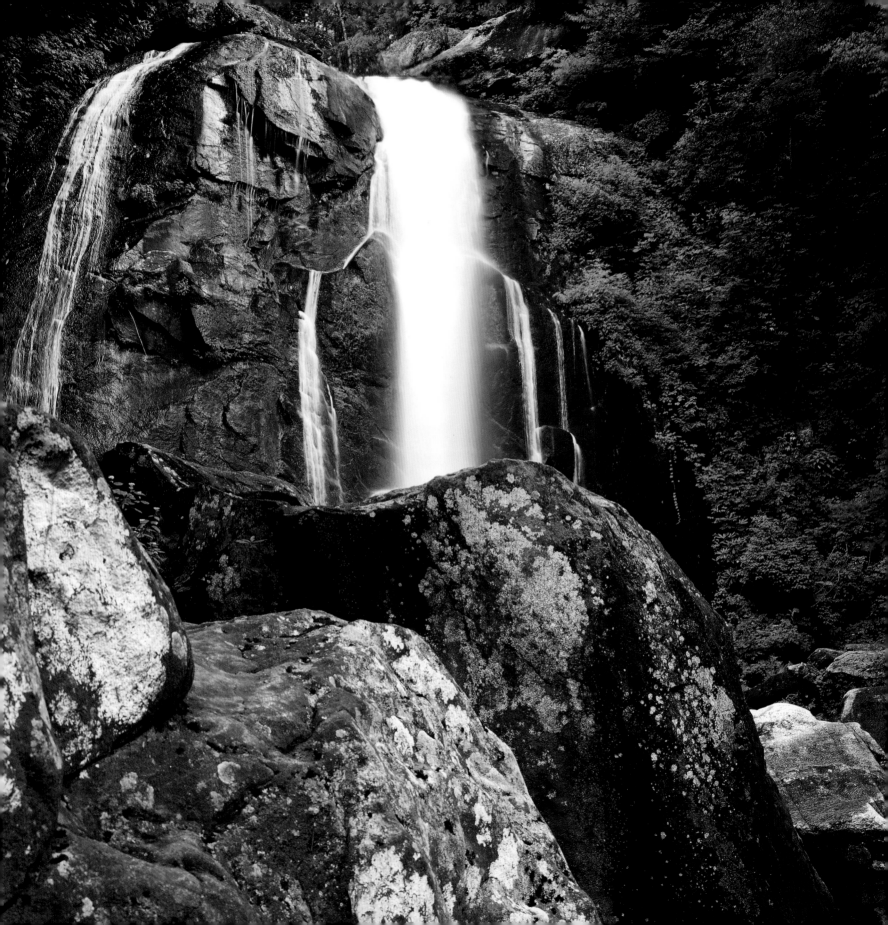

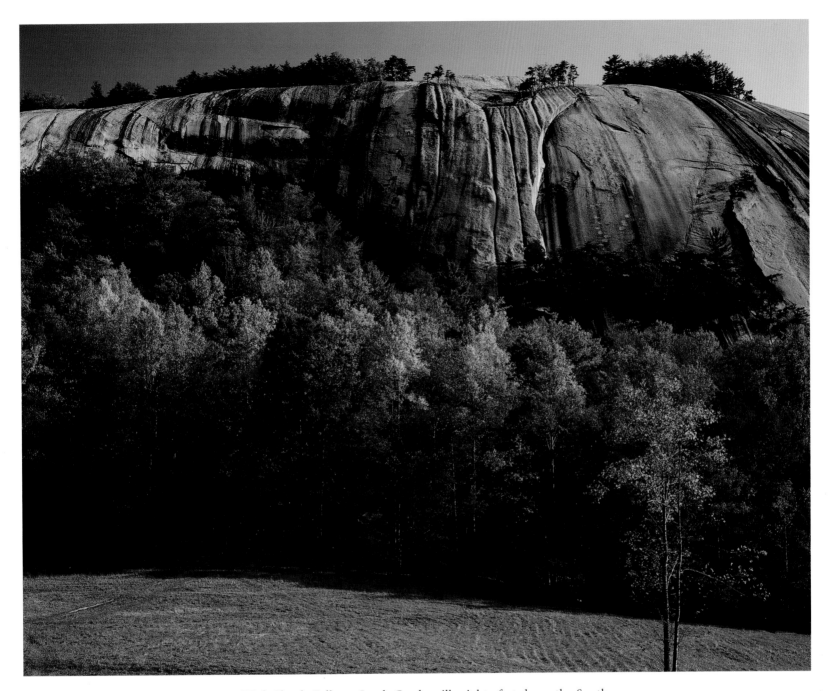

◄ High Shoals Falls on Jacob Creek spills eighty feet down the South
Mountains before forming a series of cascades. Situated in southwestern
Burke County, South Mountains State Park encompasses 7,225 acres.
▲ Stone Mountain, located in 13,747-acre Stone Mountain State Park,
is a monolithic dome rising 2,305 feet above sea level. It is composed of
Paleozoic granite that formed eons ago when lava from a volcanic erup-
tion was deposited on the original bedrock.

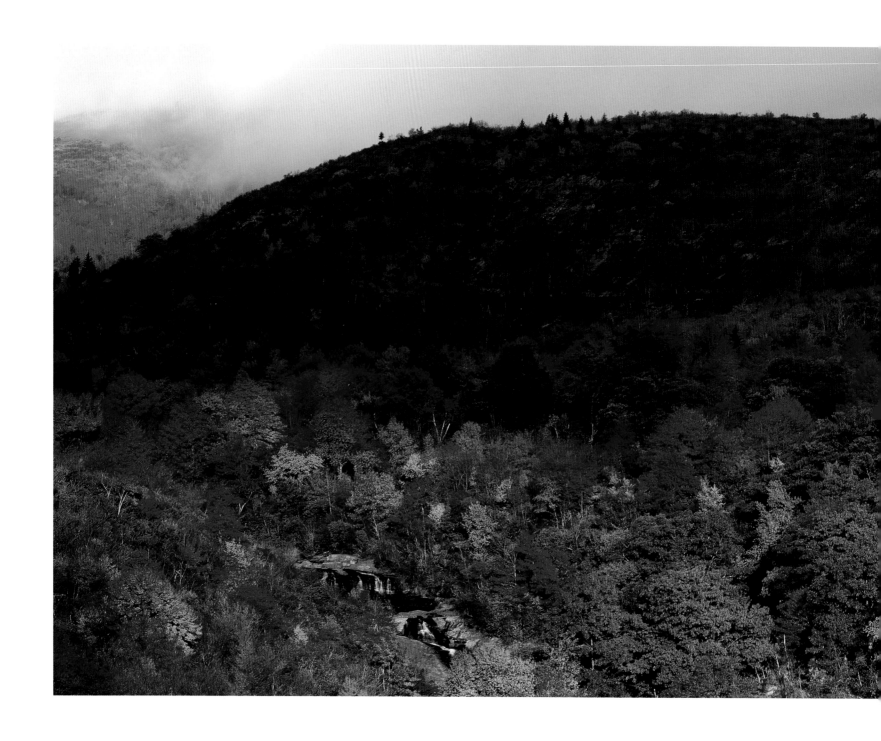

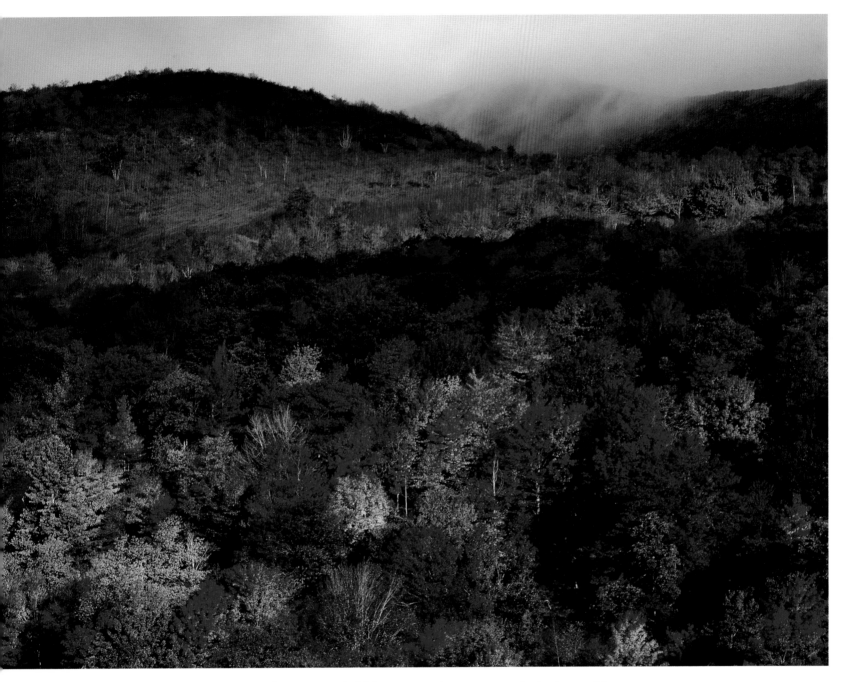

▲ Below Graveyard Fields, sugar maples seem to set the landscape ablaze. In autumn, the leaves of the sugar maple provide a feast for the eyes with colors ranging from clear yellow to deep crimson to brilliant red.

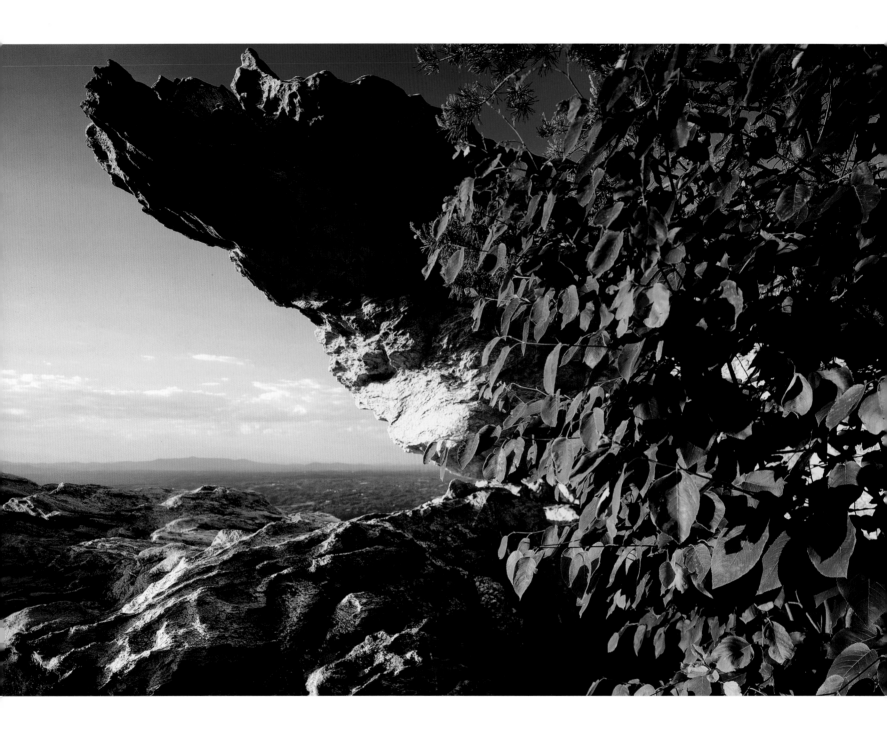

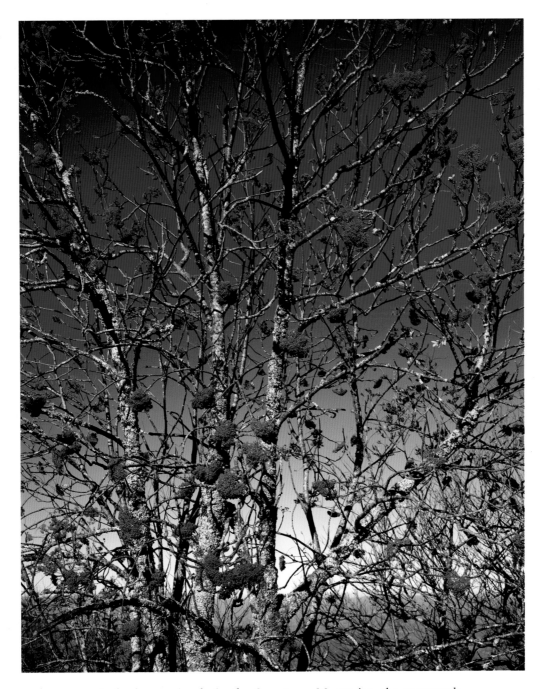

◄ Lodged precariously in the Sauratown Mountains, the mammoth, jagged Hanging Rock at Hanging Rock State Park is composed of quartzite.
▲ The mountain ash, not actually an ash, is a member of the rose family.
► ► Cinnamon ferns line Linville Falls in Linville Gorge Wilderness. The Linville River has carved a spectacular gorge in its two-thousand-foot descent from the Blue Ridge Escarpment.

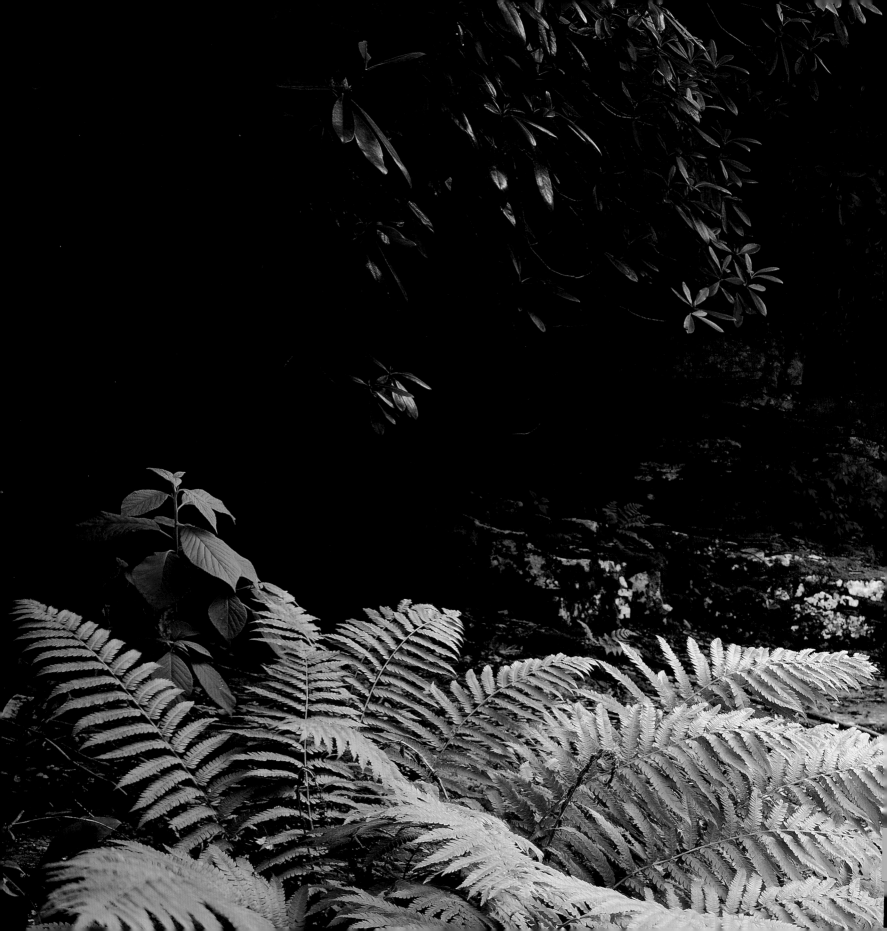

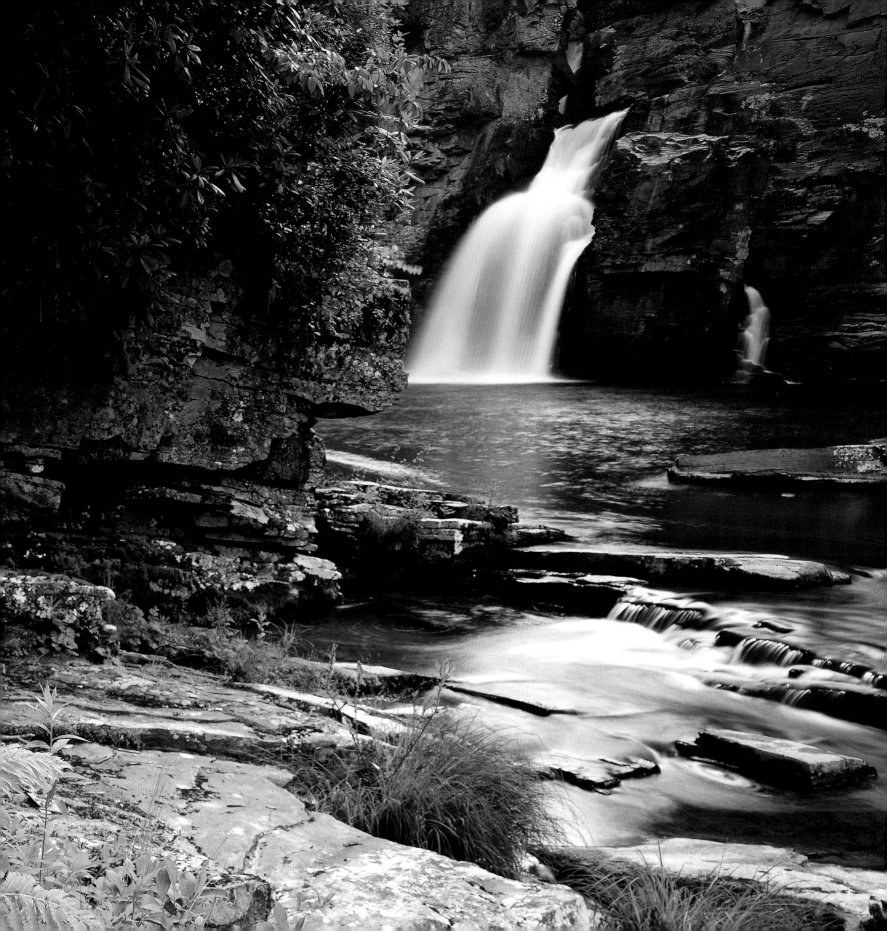

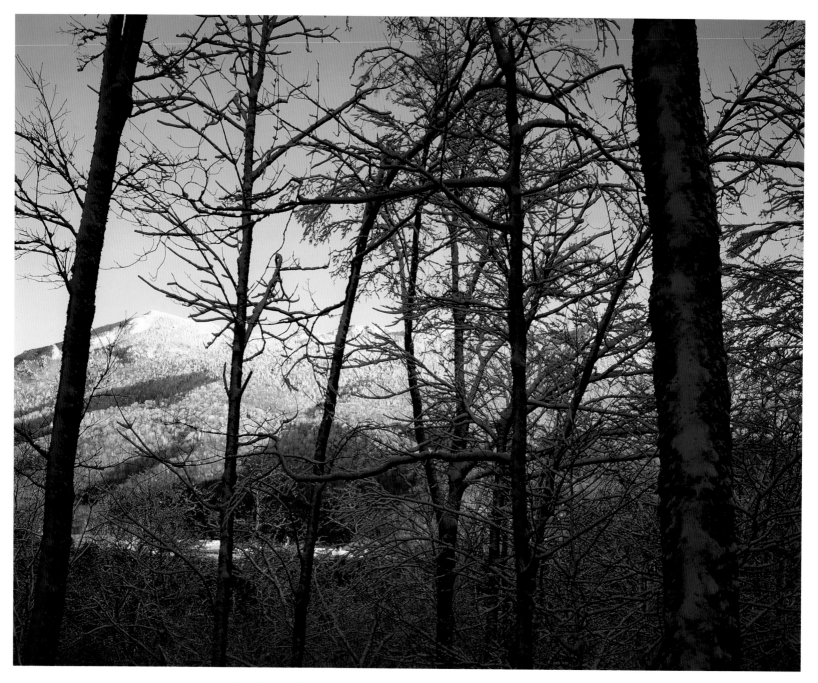

▲ Grandfather Mountain is seen through the trees from Sugar Mountain. Gale-force winds have been recorded on Grandfather, and the lowest temperature recorded on the mountain, –25°F, was on January 30, 1966.

▶ Catawba Falls, in Pisgah National Forest, drops in five successive stages as it cascades 150 feet down the mountainside. In the 1980s, the National Park Service purchased 1,028 acres, including the falls.

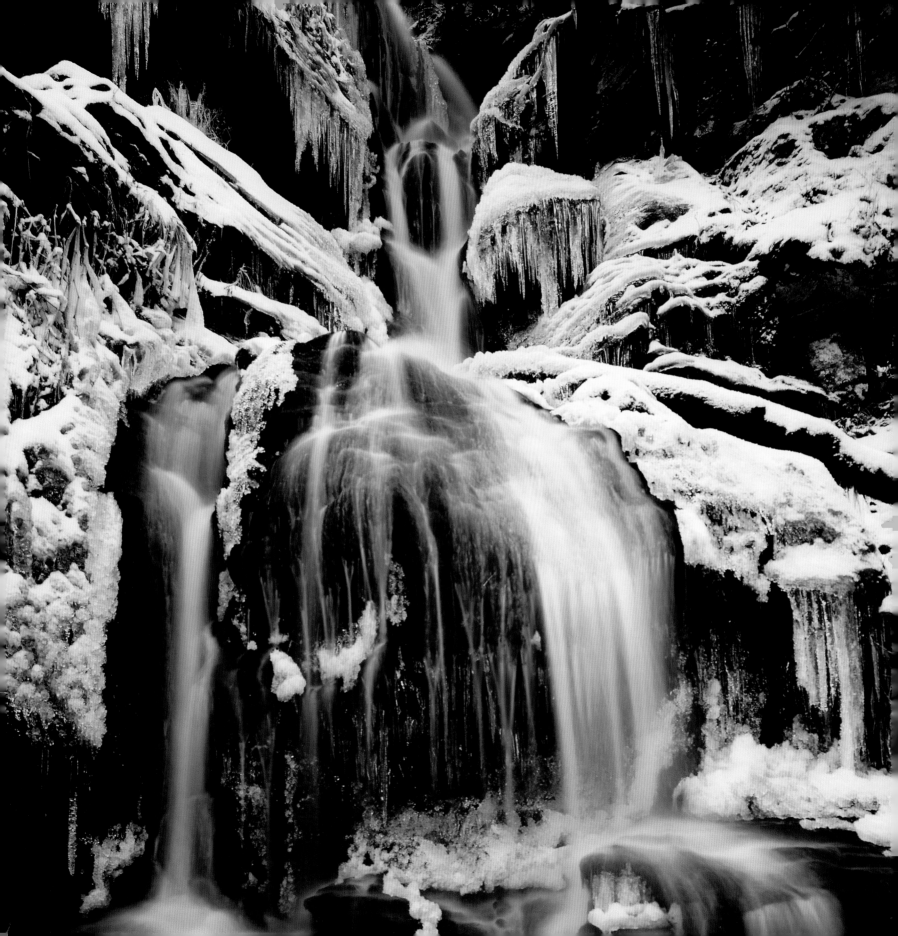

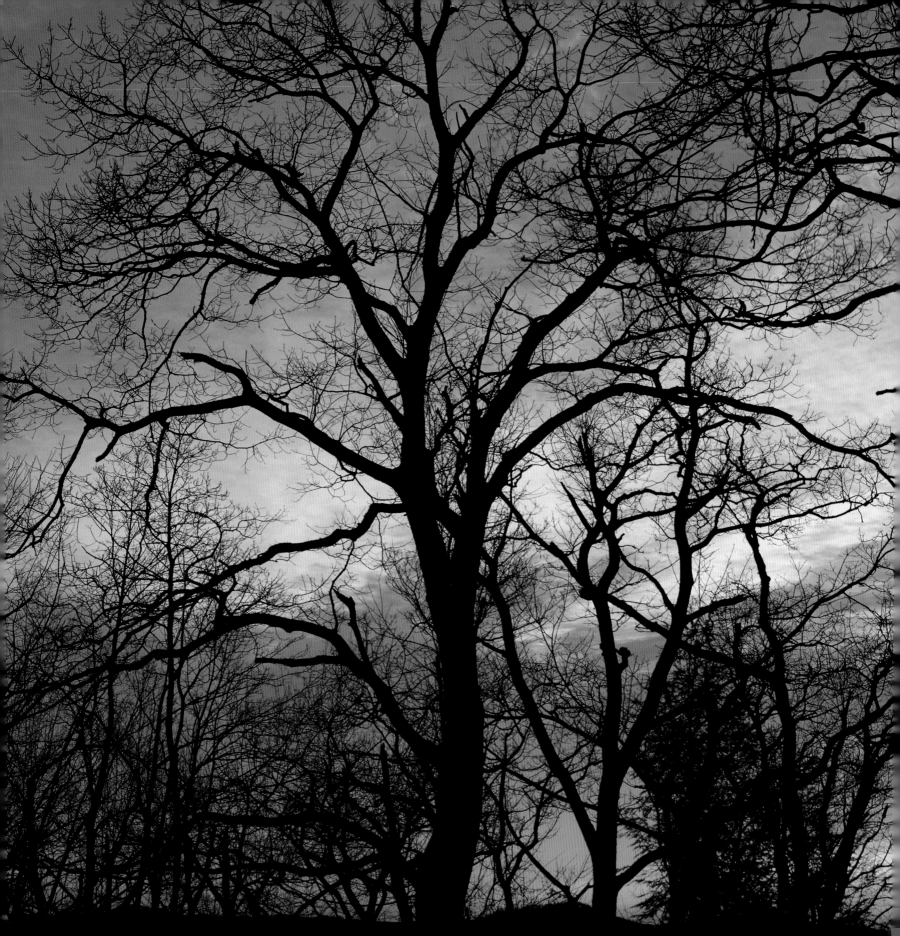

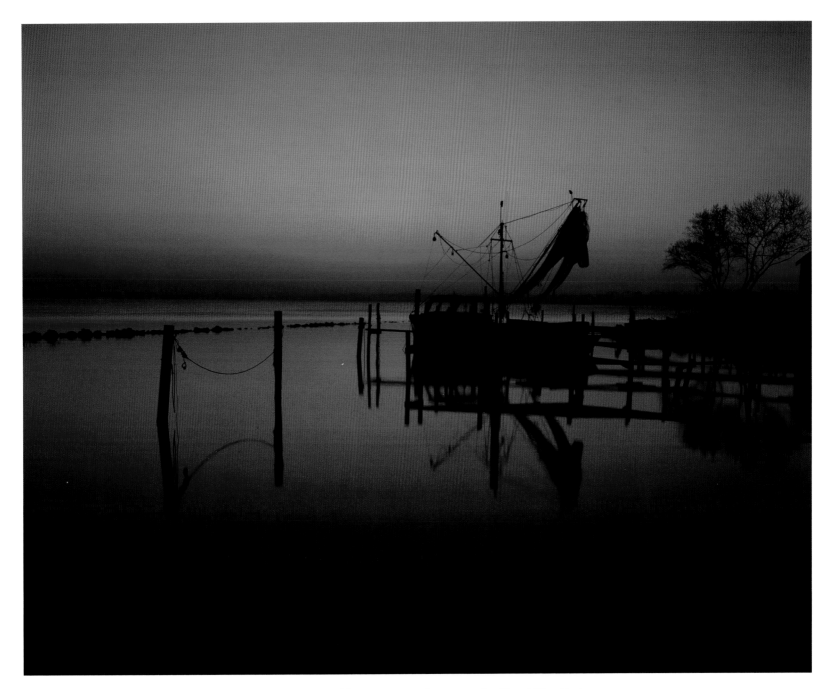

◄ A winter sunrise silhouettes an oak tree on the Blue Ridge Parkway.
▲ An old shrimp boat, with decks of yellow pine and a hull fashioned of cypress, greets the dawn at Core Sound. North Carolina has seven sounds: Albemarle, Bogue, Core, Croatan, Currituck, Pamlico, and Roanoke.

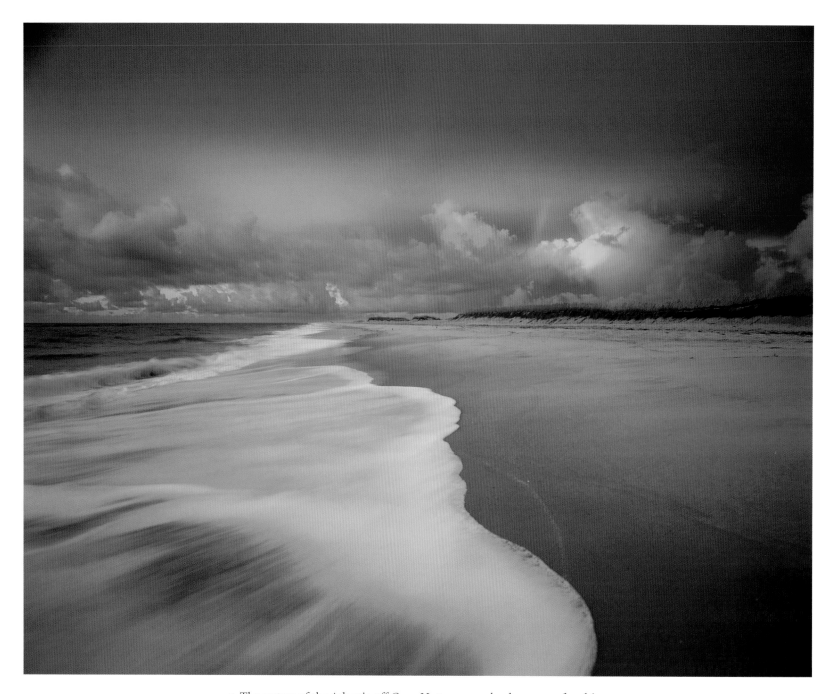

▲ The waters of the Atlantic off Cape Hatteras may be dangerous for shipping; however, they are the elixir of life for countless marine species.
▶ Bald cypress stand amid sugar maples at Merchants Millpond State Park in Gates County. The state's Natural Heritage Program identifies 36 species of mammals, 206 species of birds, 68 species of reptiles and amphibians, 28 species of fish, and 352 vascular plants at Merchants.

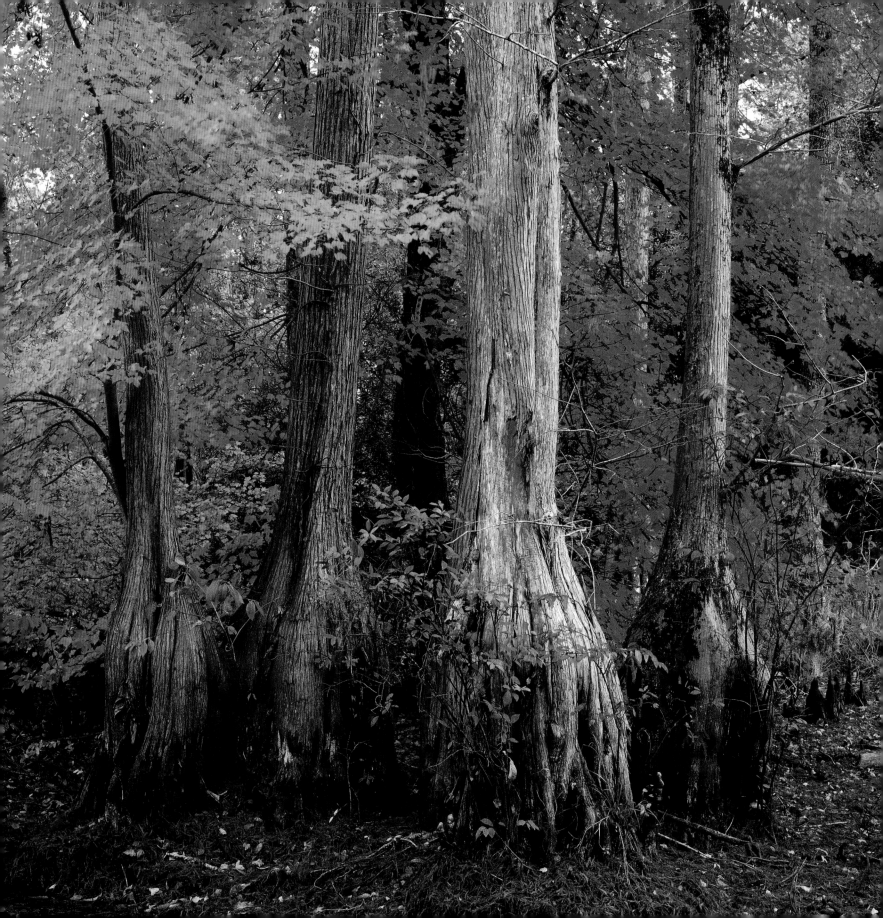

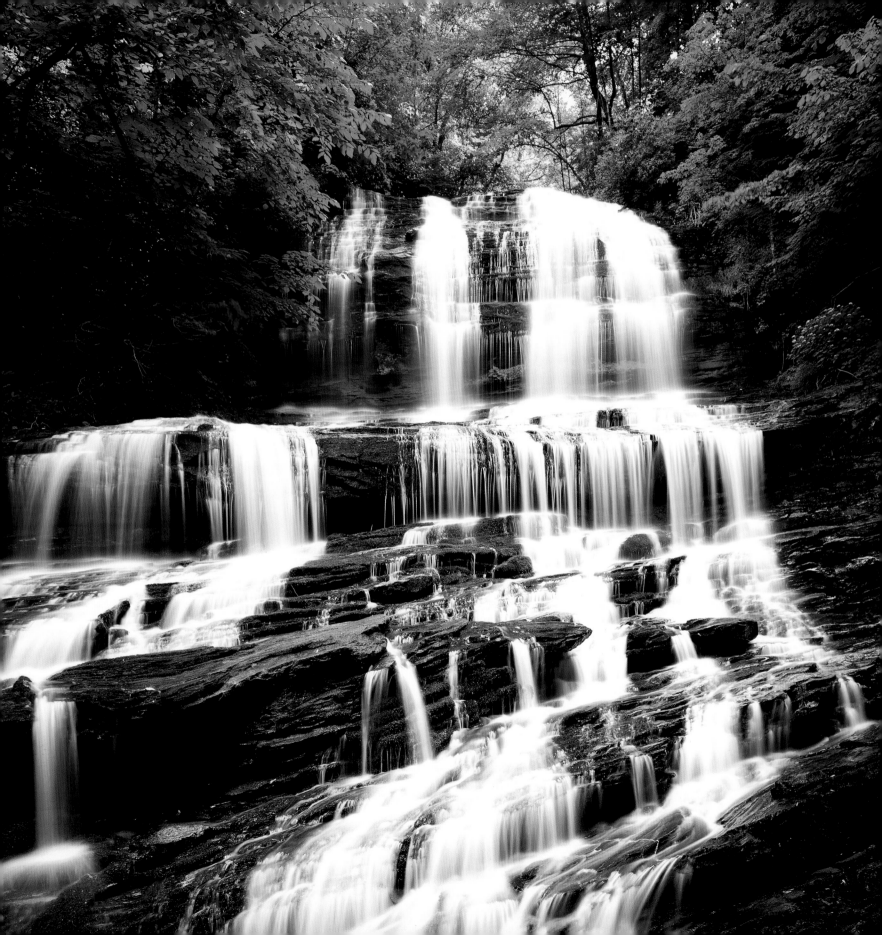

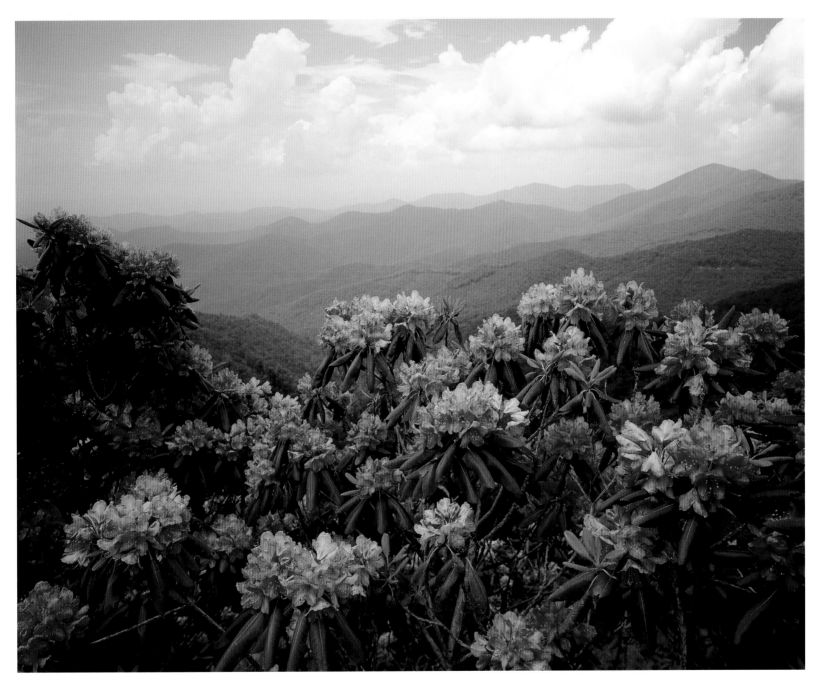

◀ Pearson Falls is a ninety-foot cascade owned by the Tryon Garden Club in Polk County. The falls are situated in the midst of a lovely secluded glen.
▲ Along the Blue Ridge Parkway, rhododendron blossoms brighten the foreground, with the Walnut Mountains fading into the distance.

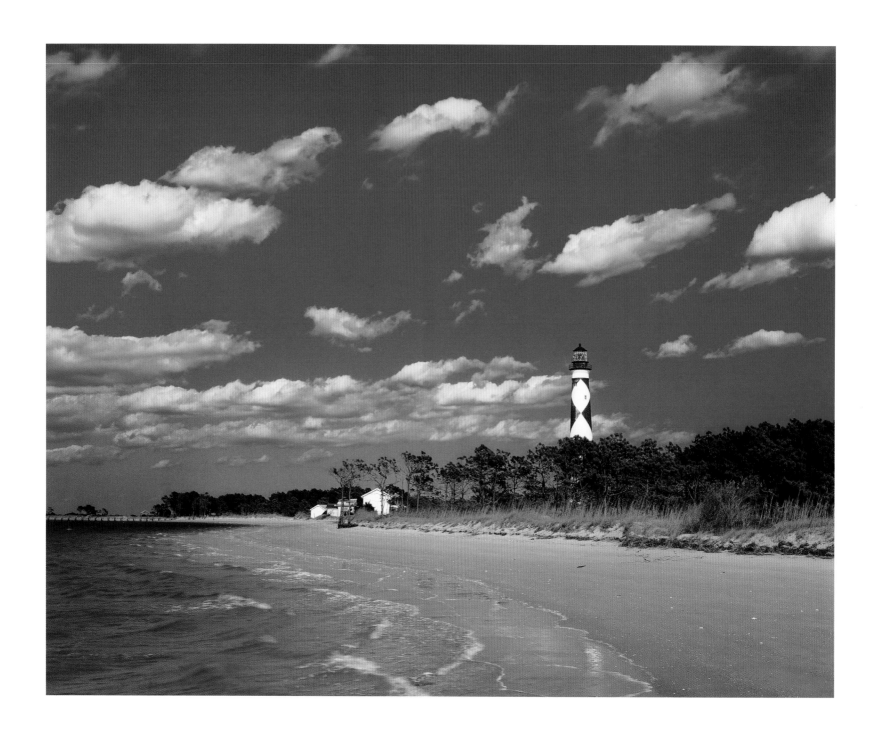

◄ The present Cape Lookout Lighthouse, completed in 1859, soars 163 feet above the surrounding area. Its beam is visible for eighteen miles.

▲ Red poppies have been planted by the state to beautify roadsides.

► ► Fog nearly envelopes even the Blue Ridge peaks as it slides into the Mills River Valley along the Blue Ridge Parkway.

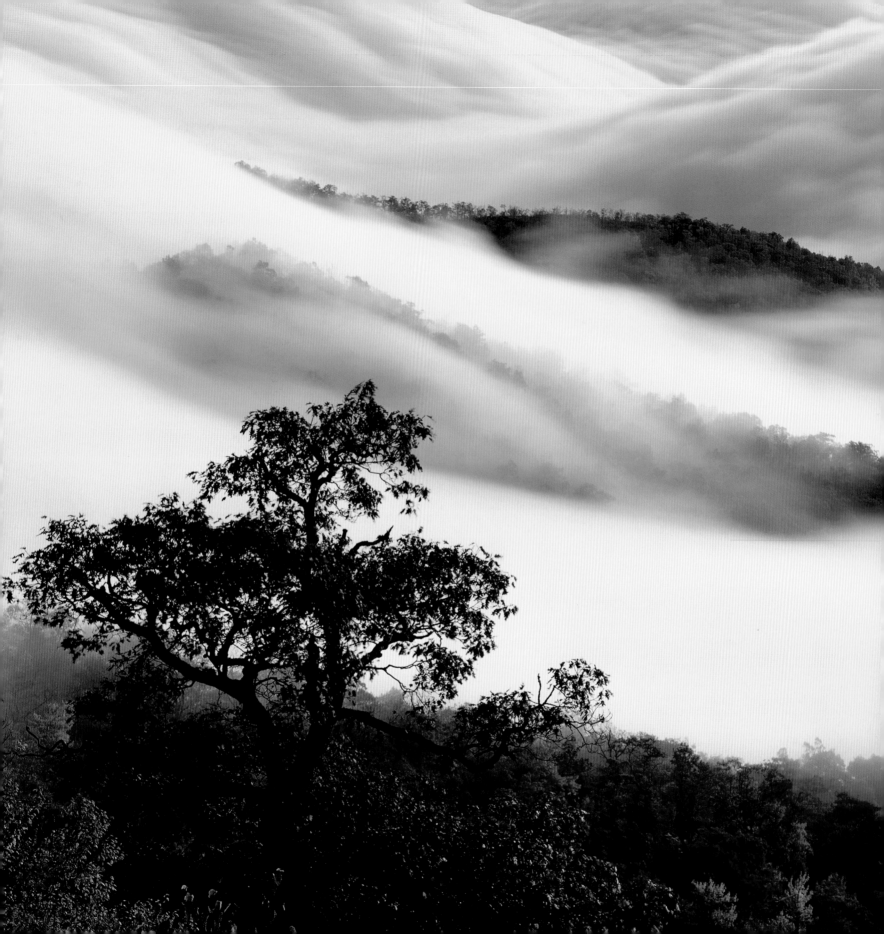

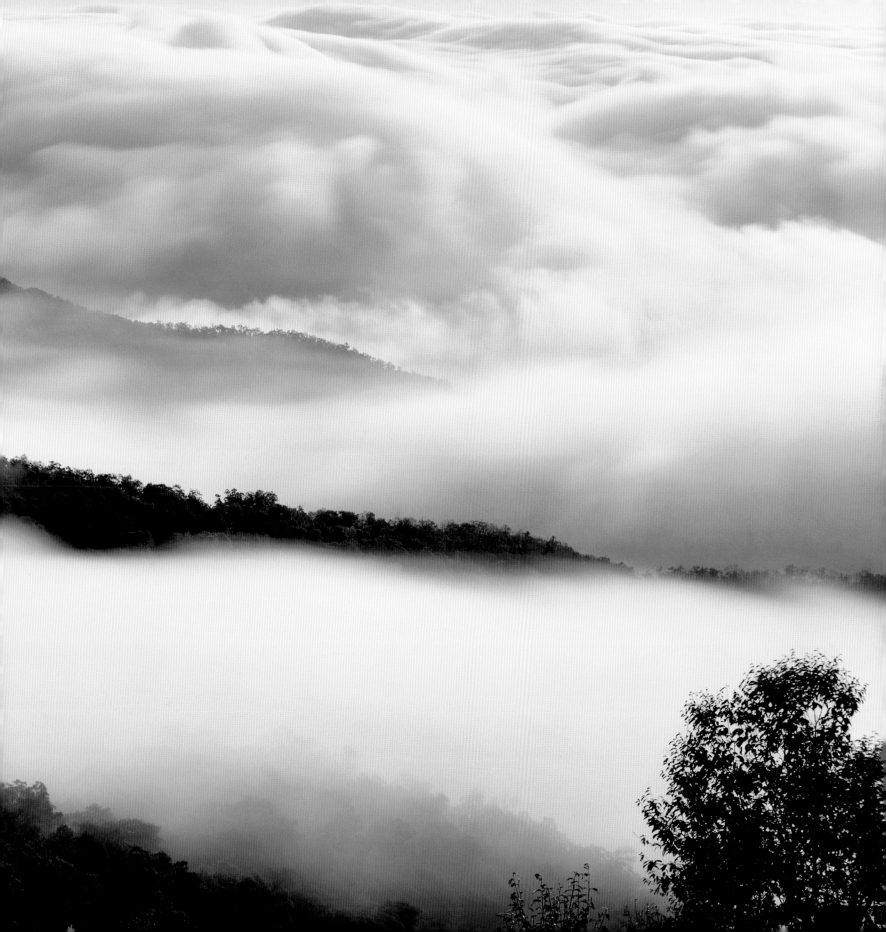

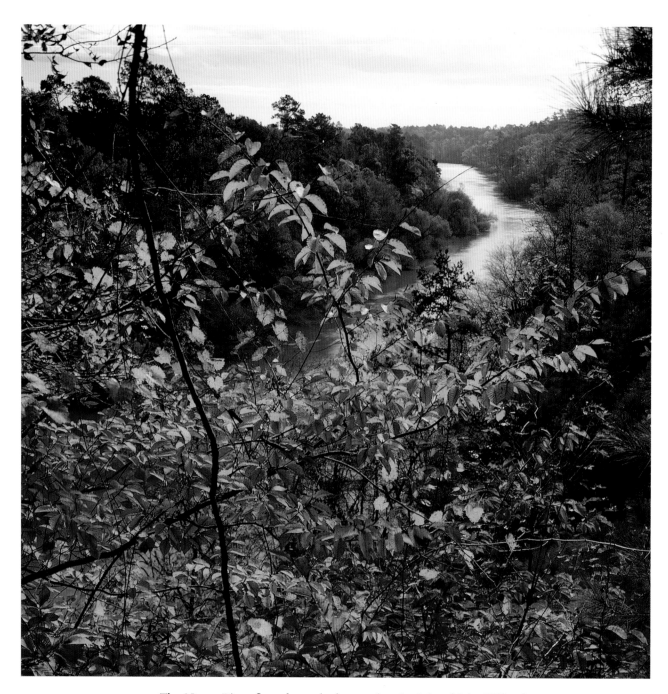

▲ The Neuse River flows beneath the one-hundred-foot-high Cliffs of the Neuse. The cliffs are made up of layers of sand, gravel, and limestone that was deposited during the Cretaceous and Pleistocene periods.
▶ Whitewater Falls in Transylvania and Jackson Counties plummets 411 feet into the Whitewater Gorge in two fantastic drops. Wet areas around waterfalls are extremely slick and dangerous. Over the years, seventeen people have lost their lives at Whitewater Falls.

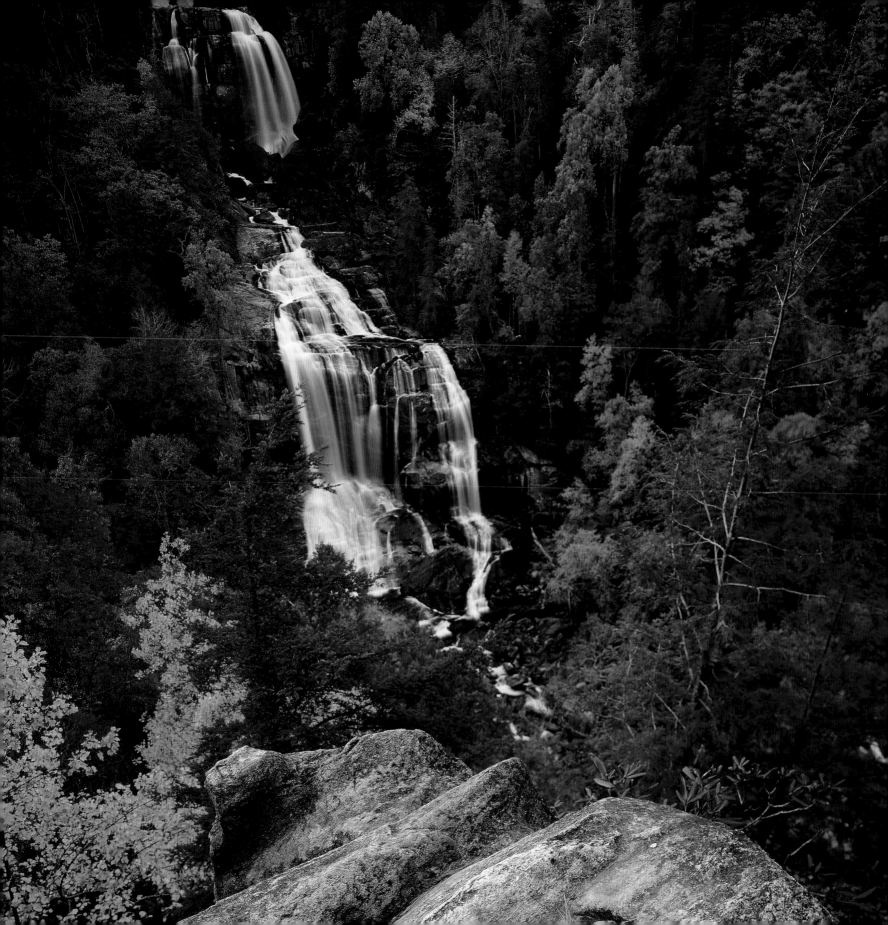

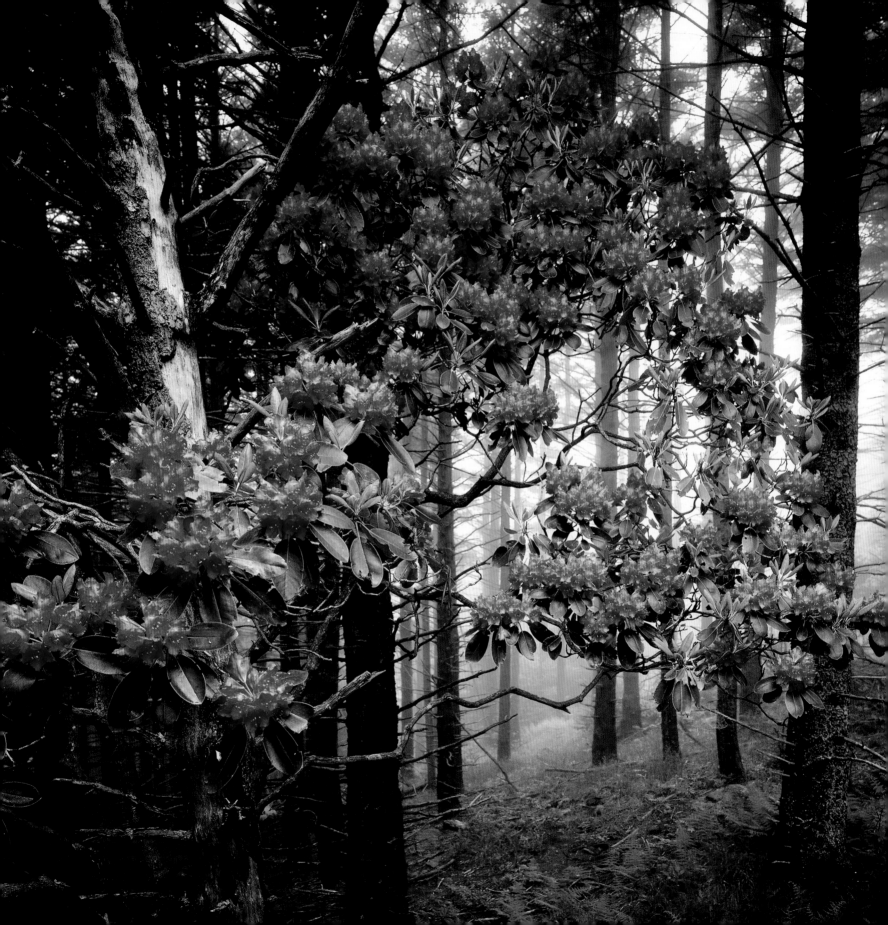

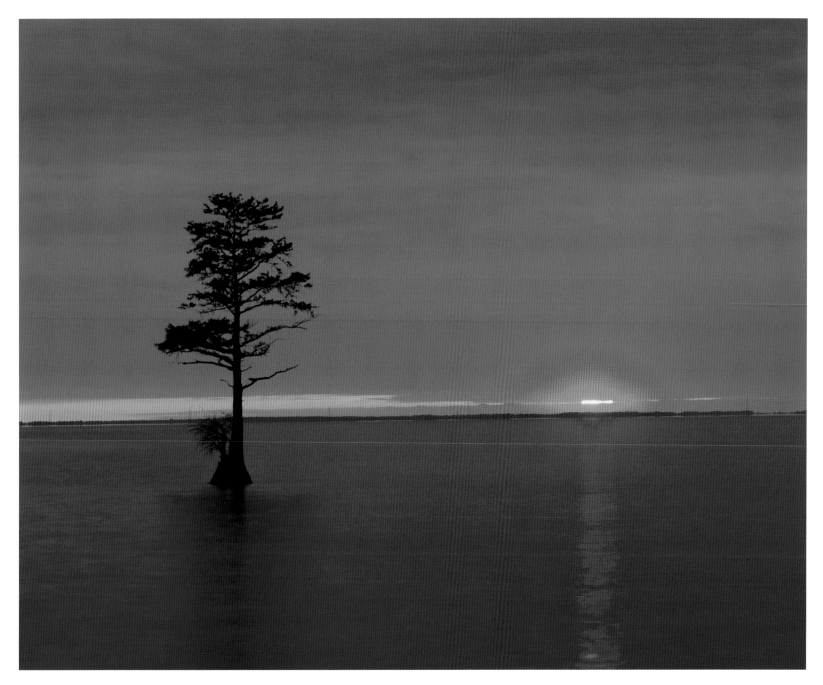

◄ Catawba rhododendron *(Rhododendron catawbiense)* blooms in a spruce-fir forest on Mount Mitchell. This evergreen shrub of the heath family can reach heights of more than thirty feet; the trunks, a diameter of as much as twelve inches. A single plant may boast hundreds of blossoms.
▲ A lone cypress tree rises above Albemarle Sound at sunset.

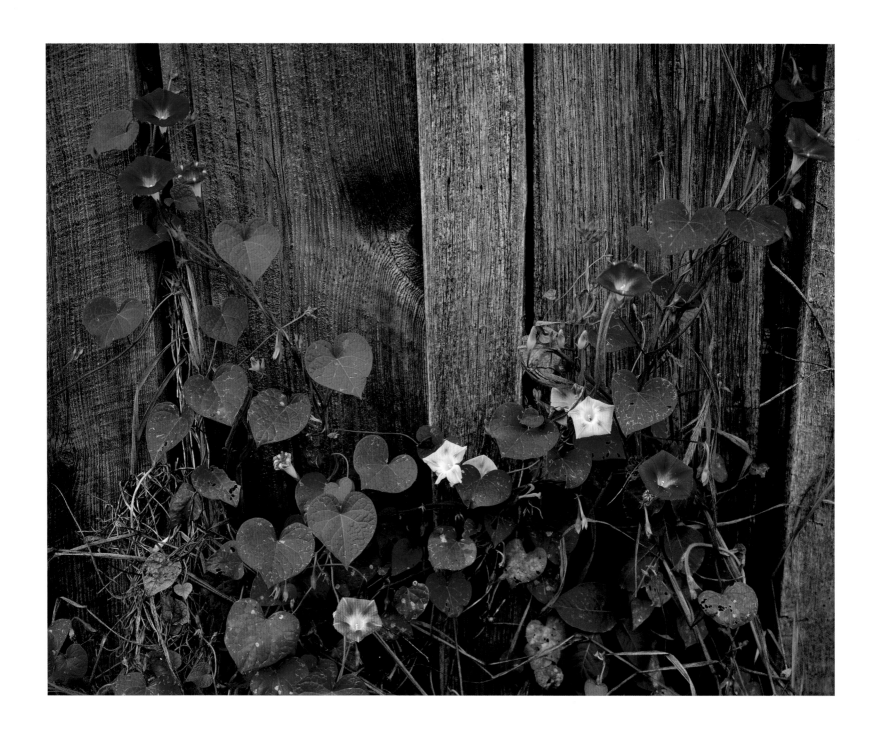

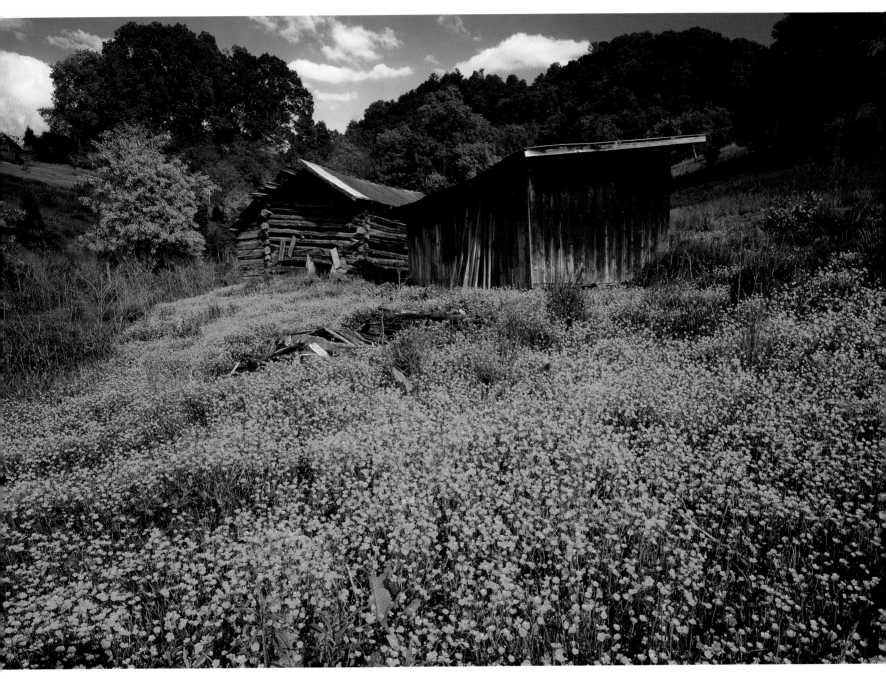

◄ In Haywood County, morning glories make even an old barn beautiful.
▲ Old tobacco sheds stand sentinel over a field of buttercups that now cover ground where tobacco used to grow.

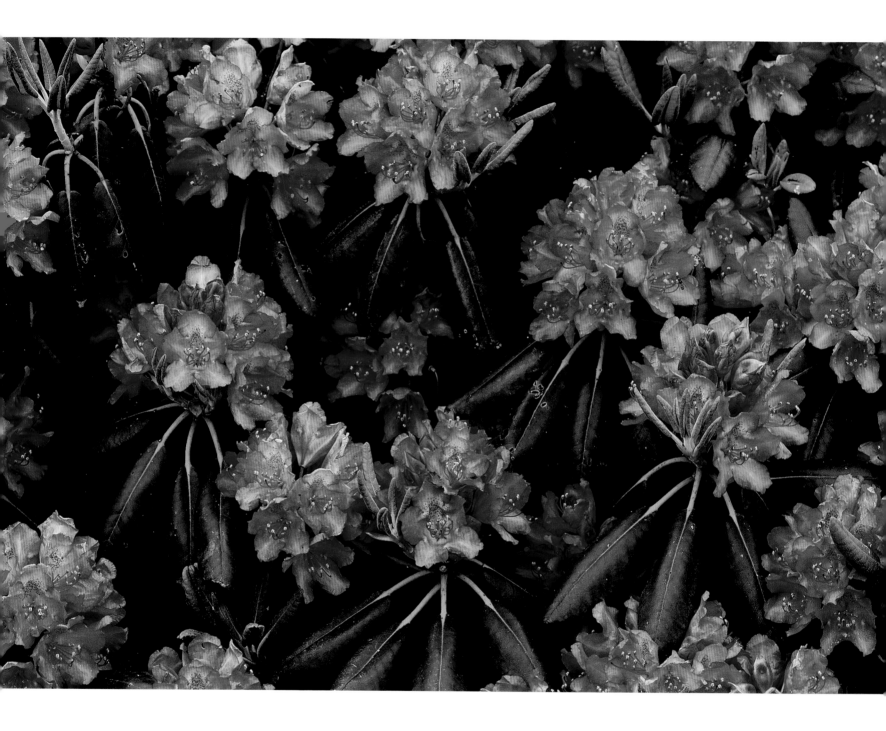

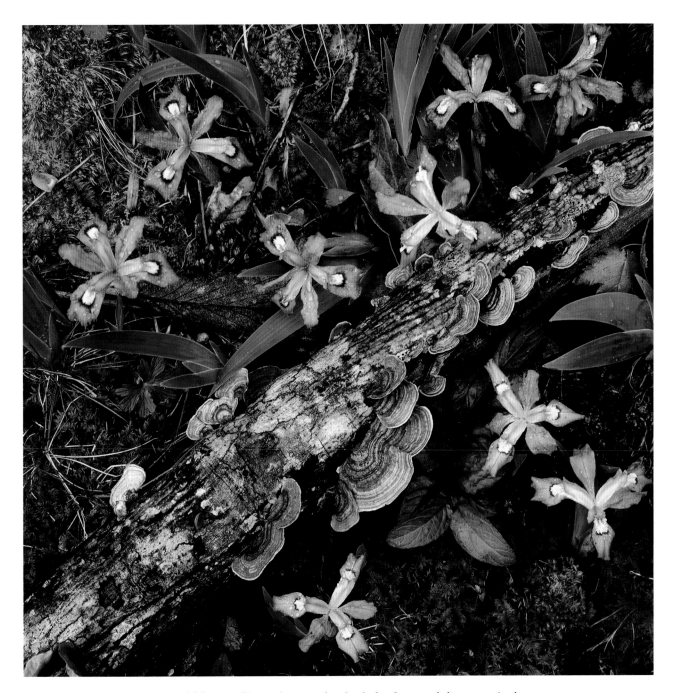

◄ Bumblebees pollinate the catawba rhododendron, and the nectar is also a favorite food source for the ruby-throated hummingbird. During the winter, the evergreen leaves swivel into tight rolls to conserve heat.
▲ Crested dwarf iris *(Iris cristata)* and turkey tail fungus add beauty to what might otherwise be just a dead branch. Out of decay and death come renewal and life—nature's way of creating the world anew.

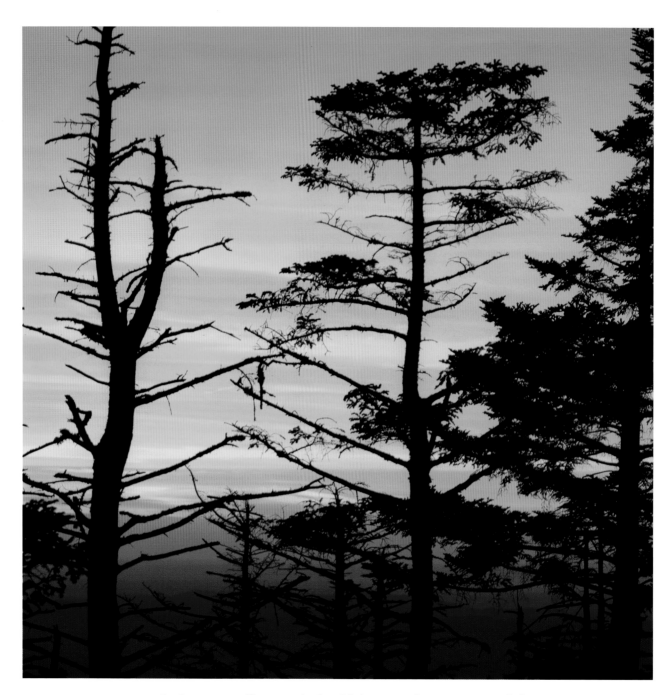

▲ A winter sunset silhouettes dead and living Fraser firs at Mount Mitchell State Park, which stretches across the crest of the Black Mountains. The state purchased the land in 1915 to preserve the virgin spruce-fir forest.
► Cypress line the Waccamaw River. A unique blackwater stream, the river consists of levees, oxbows, sloughs, and islands, more like a brownwater river—which it was when it drained from the Piedmont. Shifts in the Cape Fear fault cut off the river's upper reaches, creating a blackwater river.

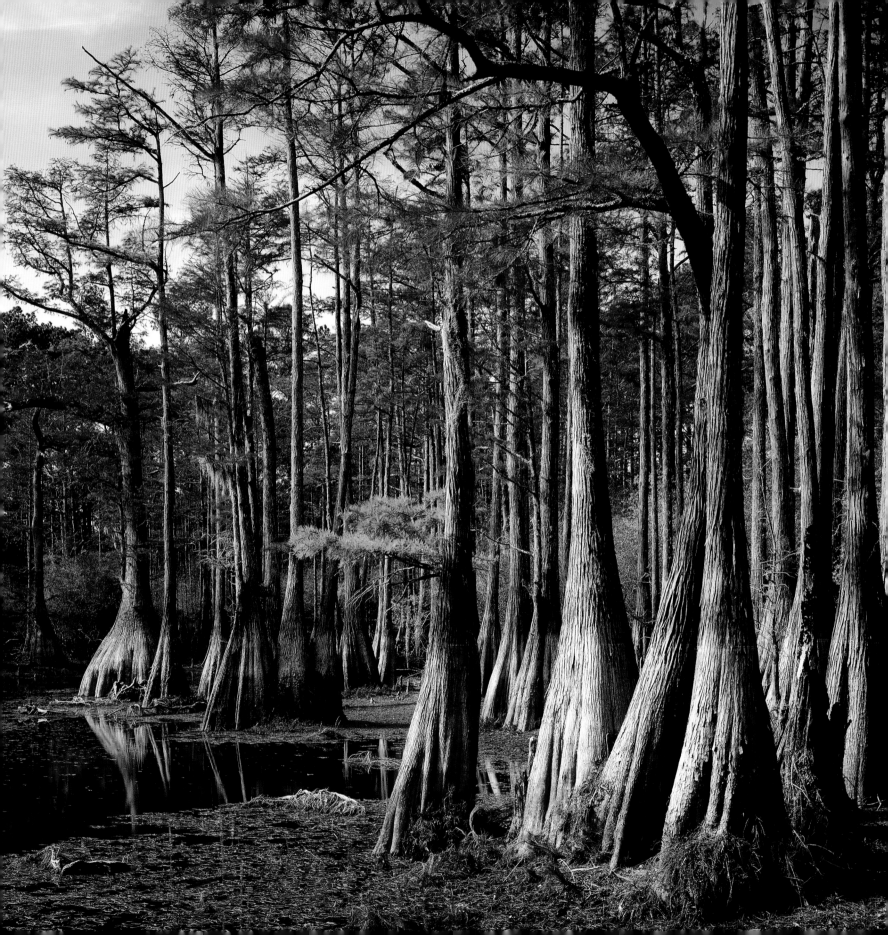

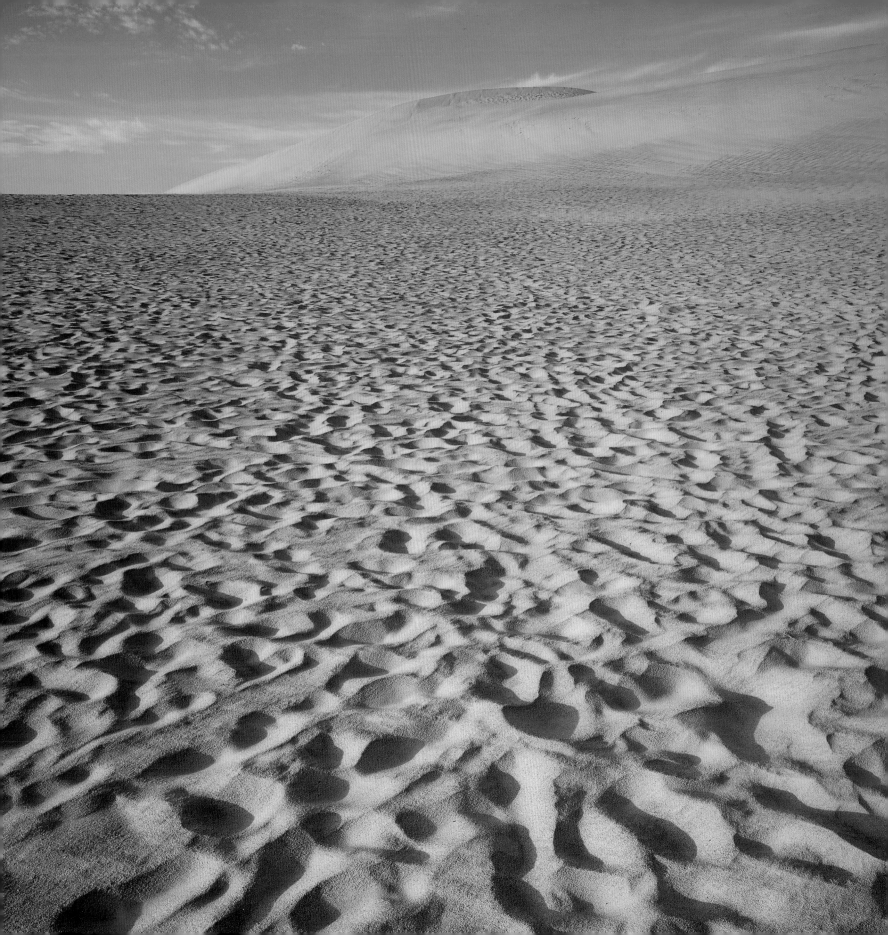

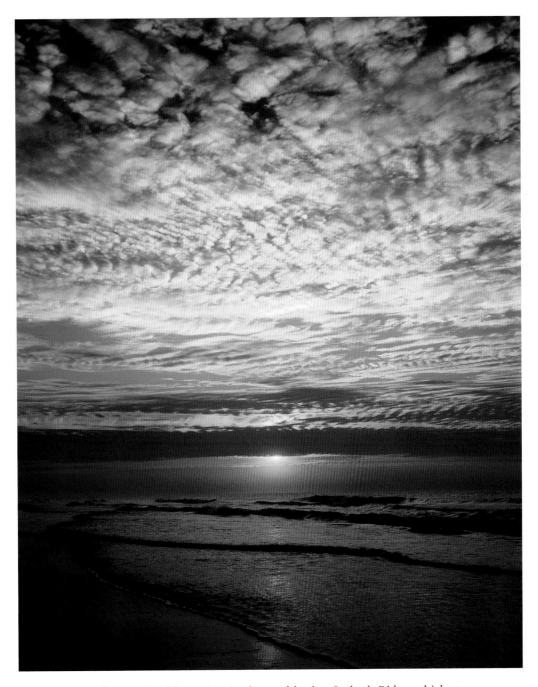

◀ Thousands of footprints in the sand lead to Jockey's Ridge, which at 140 feet in elevation is the highest sand dune on the East Coast. The top of the dunes is a favorite launching site for hang gliders and offers great views of Roanoke Sound. "Jockey's Hill" appears on a 1753 land grant.

▲ Okracoke Island, in Cape Hatteras National Seashore, offers a vivid sunrise.

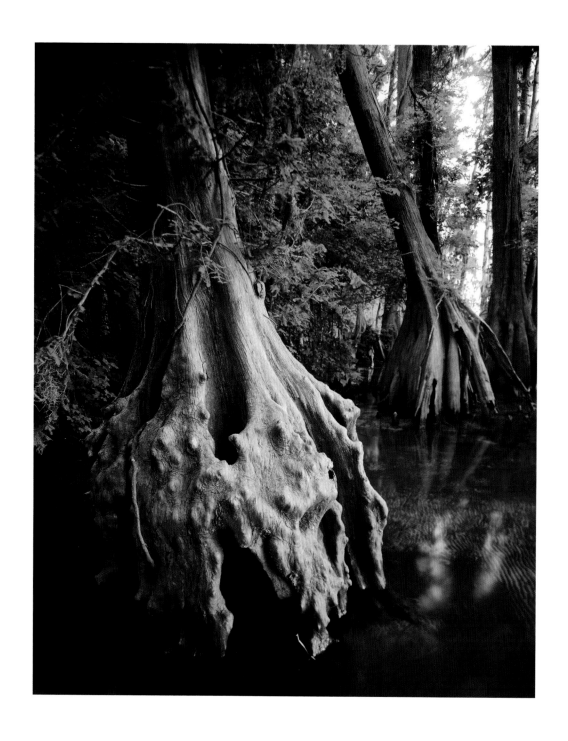

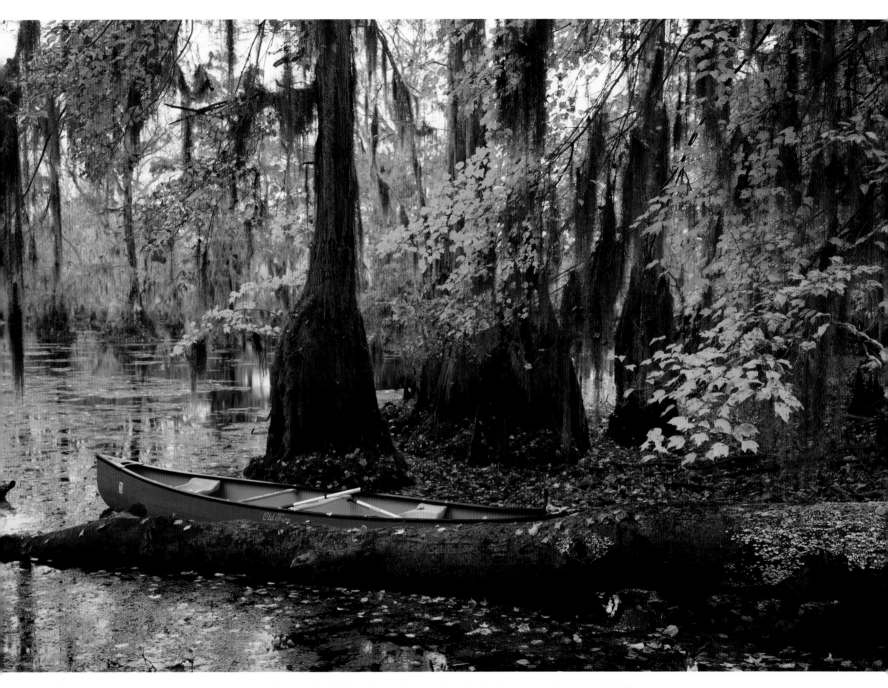

◄ Along Lake Phelps, in Pettigrew State Park, is a strip of mature bald cypress, a remnant of a swamp forest once extending over the coastal plain.
▲ One autumn day, my daughter, Katie, and I paddled through the black waters of Merchant's Millpond, constructed in 1857 by Rufus Williams. Later on, a store and a mill were built: thus the name "Merchant's Millpond."
► ► Rhododendrons gild the trail up Potato Knob in the Black Mountains. As Thoreau wrote, "Heaven is under our feet as well as over our heads!"

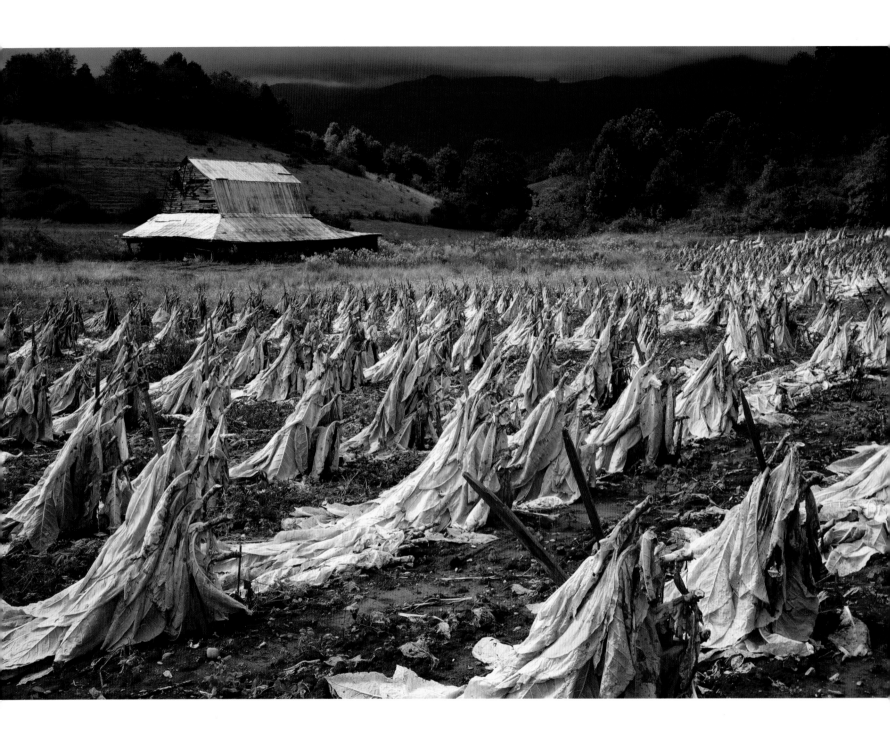

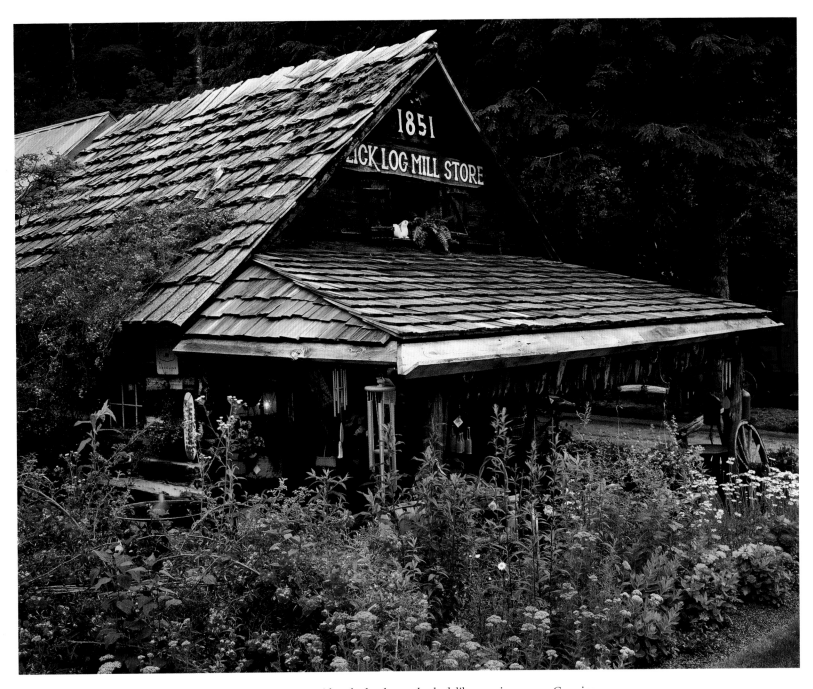

◄ My aunt once said staked tobacco looked like praying nuns. Growing tobacco has been a way of life for many families in the state for generations.
▲ The Lick Log Mill Store was built in 1851. Water-powered gristmills were common in the state until the early 1900s. These mills, like the agrarian life they represent, are vanishing today.

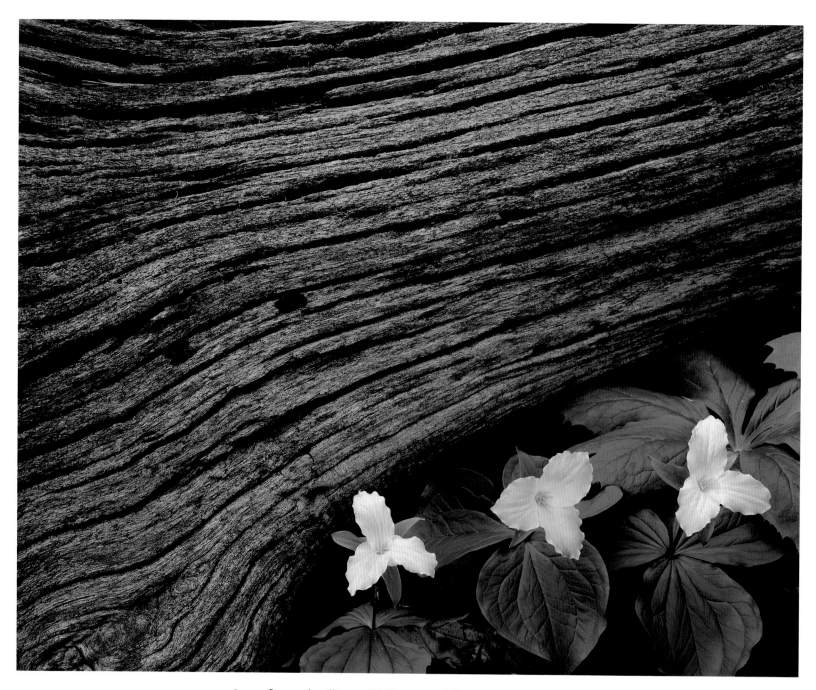

▲ Large-flowered trilliums *(Trillium grandiflorum)* decorate a chestnut log. The great stands of chestnut trees so valuable for their mast and timber are no more. The species was devastated by the chestnut blight, a fungus that was accidentally introduced from China in the early 1900s.

▶ A flame azalea *(Rhododendron calendulaceum)* flourishing in Crabtree Meadows signals spring's arrival. Like catawba rhododendron, it is part of the heath family. The blossoms vary from yellow to orange to scarlet.

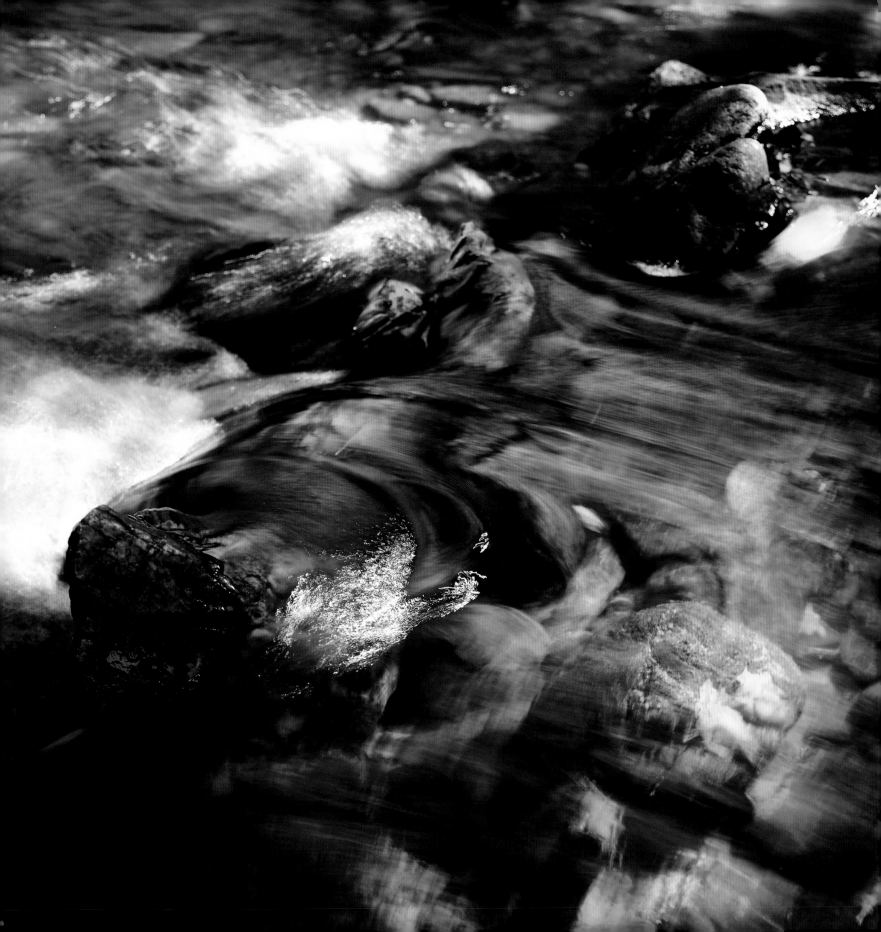

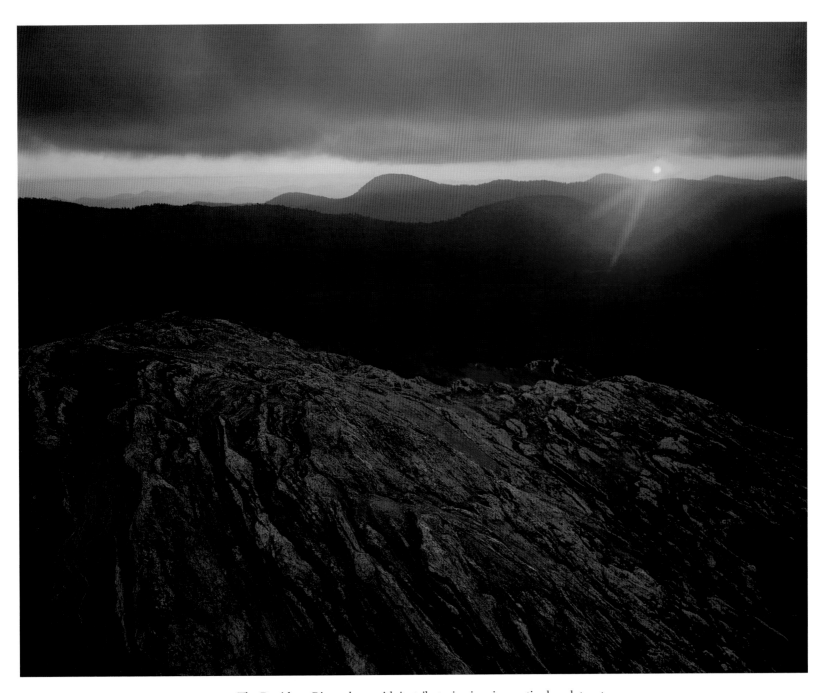

◄ The Davidson River, along with its tributaries, is prime native brook trout water. Hatchery-raised fish are also released into the river. In summer, the Davidson teems with people who enjoy swimming, fishing, and tubing.
▲ The rock outcrops on Black Balsam Knob point to the cataclysmic forces that shaped these ancient mountains.

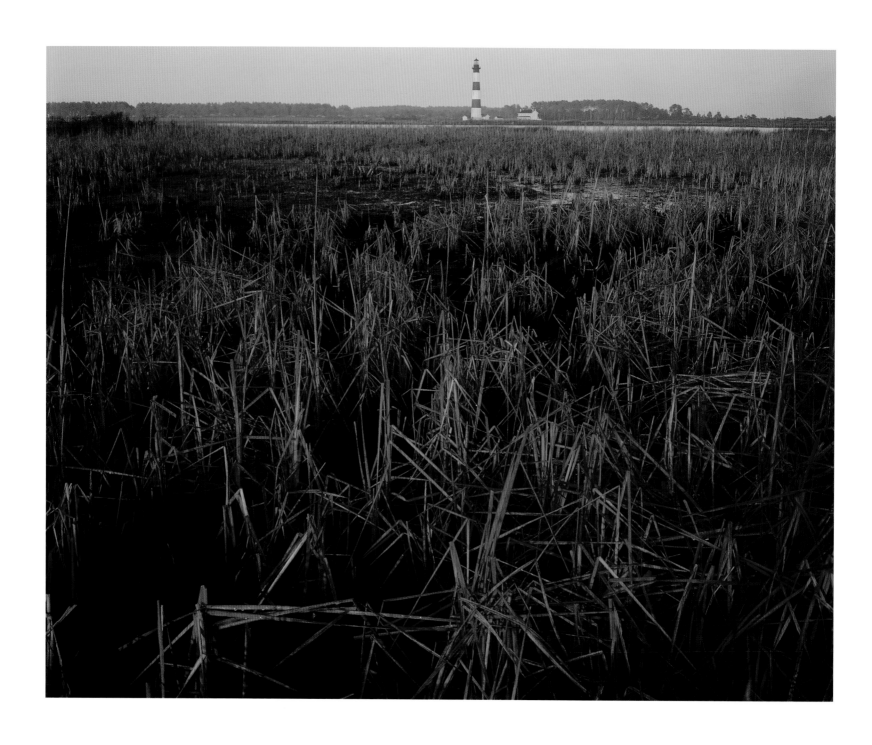

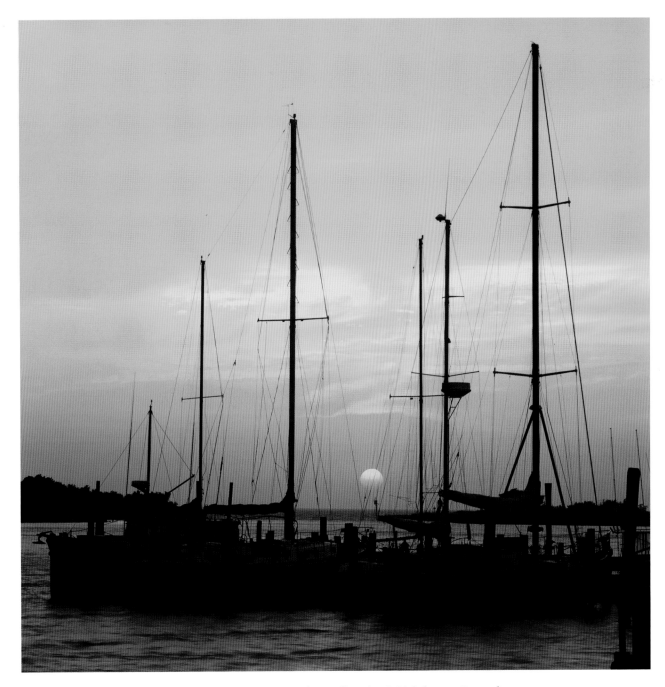

◄ Marsh reeds give way to the Bodie Island Lighthouse. Legend says Bodie Island was named for the many bodies that washed up on its shores from shipwrecks. The present Bodie Island light, 163 feet tall, began guiding and protecting ships through the perilous Oregon Inlet in 1872.
▲ The village of Ocracoke lies at the southern end of Ocracoke Island. At sunset, it is easy to visualize Edward Teach, the notorious Blackbeard, sailing into Silver Lake. The pirate terrorized the coast in the early 1700s.

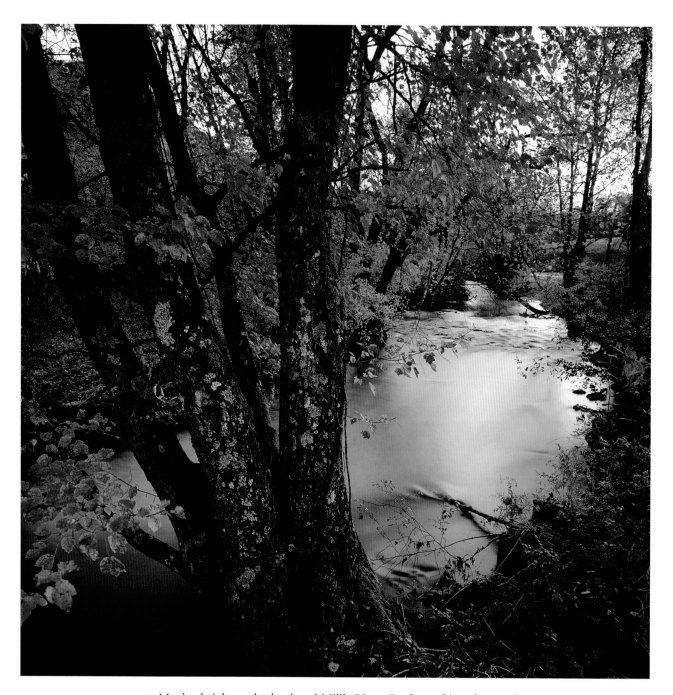

▲ Maples brighten the banks of Mill's River Creek, evoking the words
Marcel Proust wrote in *Remembrance of Things Past:* "The real voyage of
discovery consists not in seeking new landscapes, but in having new eyes."

▶ The Oconaluftee River drains the huge valley between Hughes Ridge and
Thomas Divide. Cherokee towns known as *egwanulti,* or "by the river
towns," stood along its banks. With the removal of the Cherokee in 1838,
whites settled in the area, corrupting *egwanulti* to *oconaluftee.*

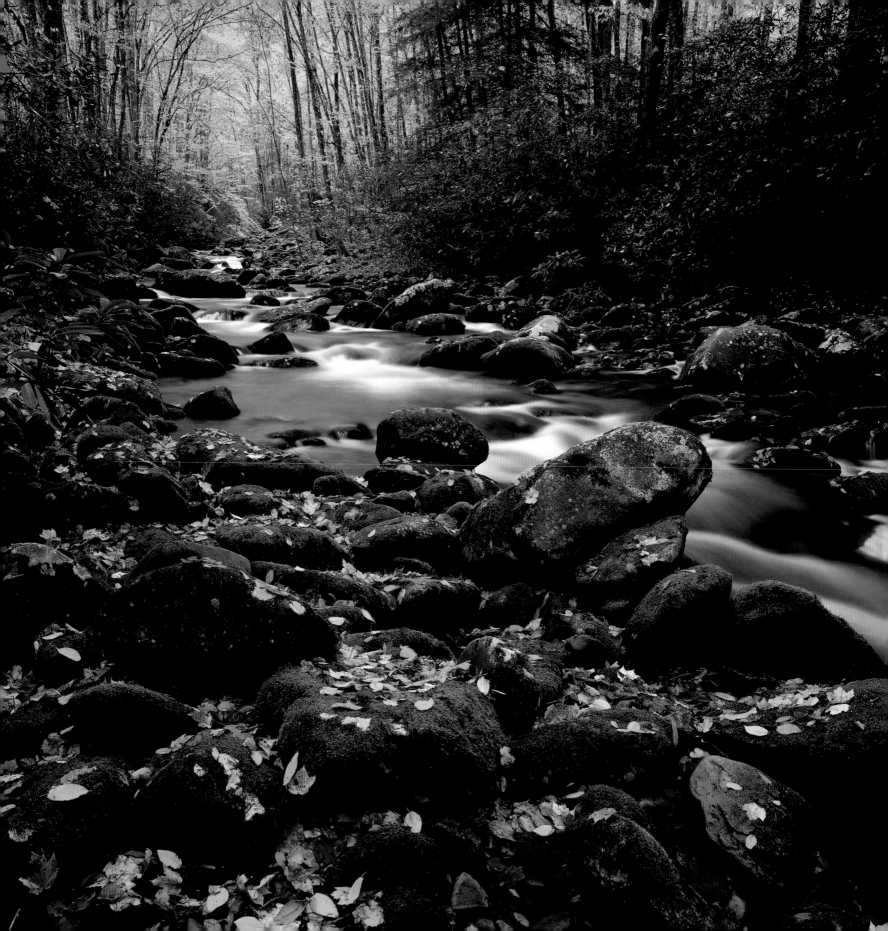

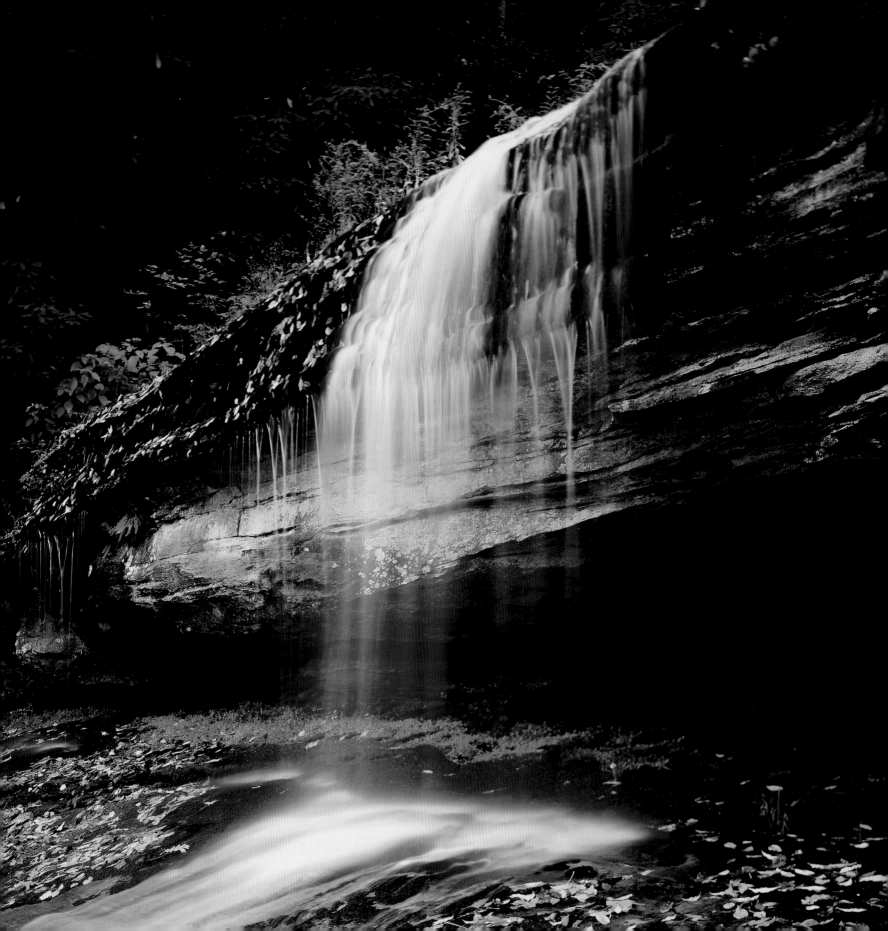

◄ A sheer waterfall in Henderson County interrupts the flow of beautiful Puncheon Camp Creek before its waters merge with Clear Creek.
▲ The sugar maple is more than just beautiful in autumn. Indians showed settlers how to tap the uniquely flavored sugar of these trees.

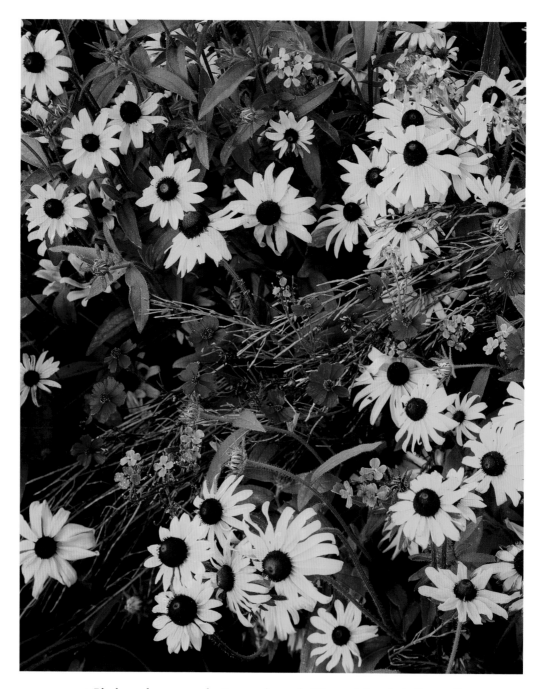

▲ Black-eyed susans evoke Emerson's words, "the earth laughs in flowers."
▶ Ocracoke Islanders say Blackbeard's body swims around Silver Lake looking for its head, which was severed in 1718 by Lieutenant Robert Maynard of the Royal British Navy in a skirmish in Ocracoke Inlet. Maynard then rigged the head on his ship's bowsprit and sailed to Virginia.
▶ ▶ The brilliant blooms of forsythia decorate the Oconaluftee Pioneer Homestead in Great Smoky Mountains National Park.

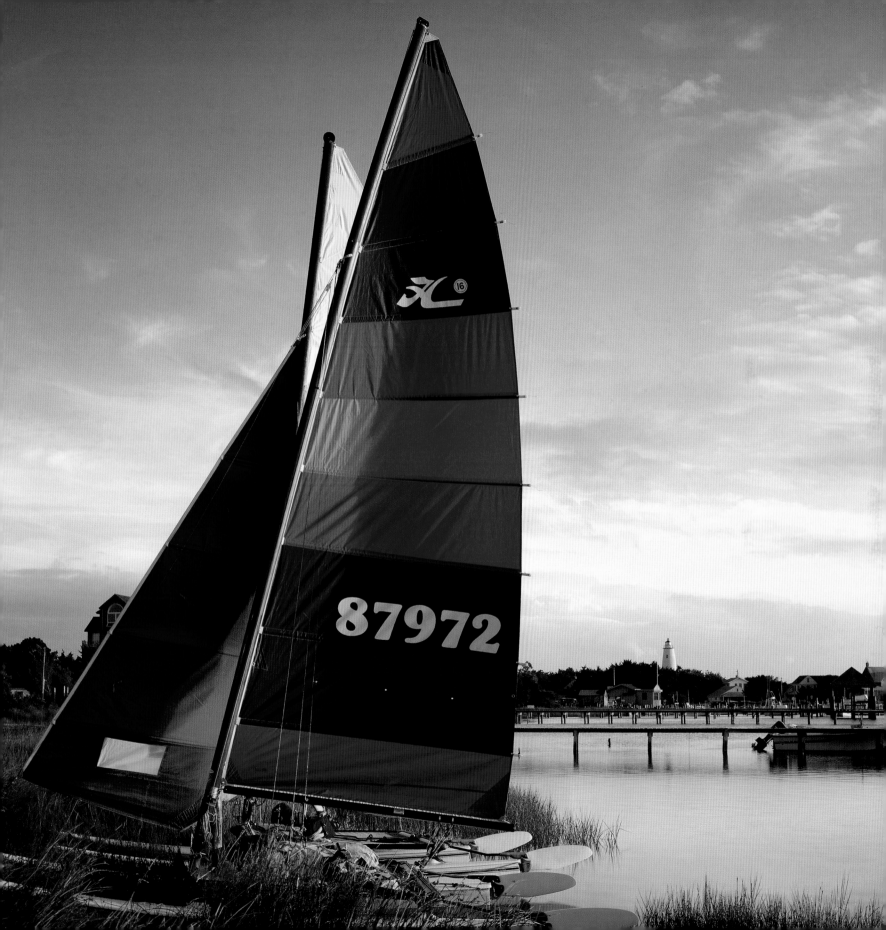

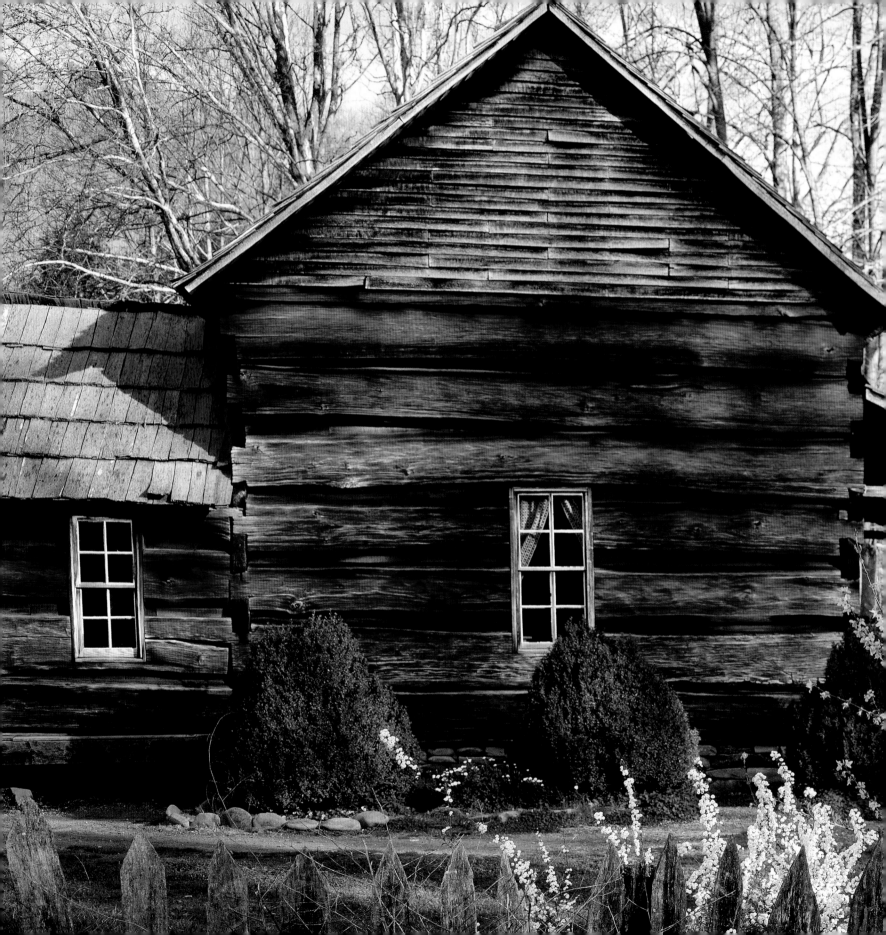

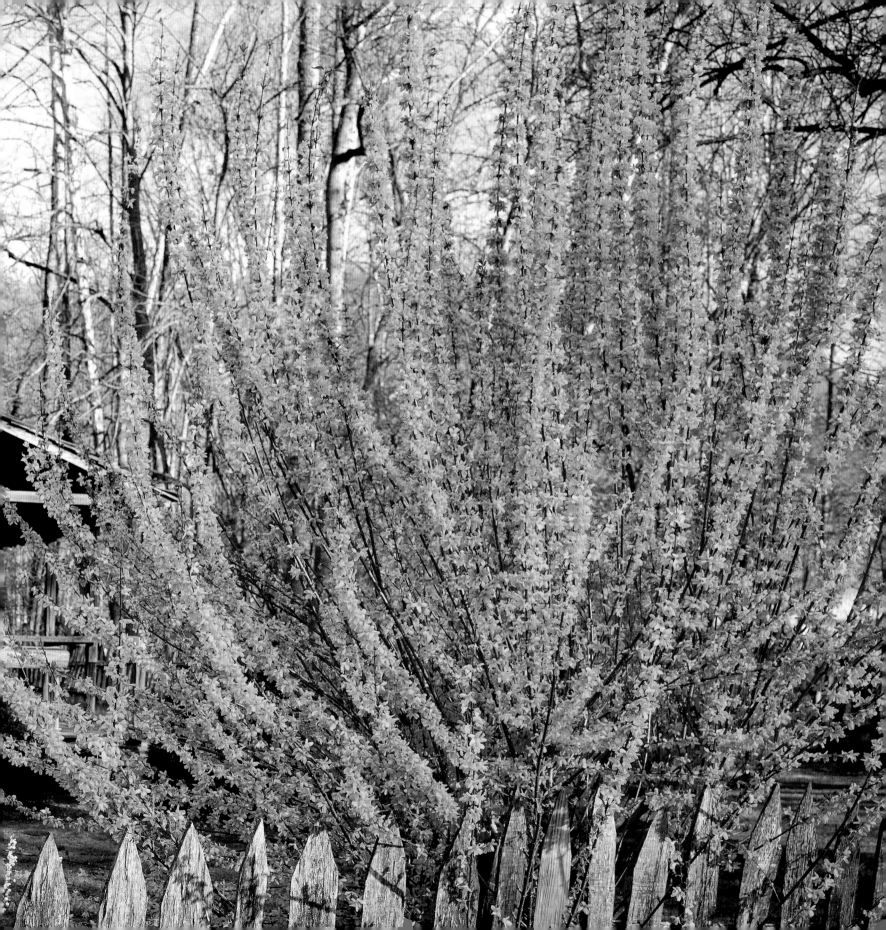

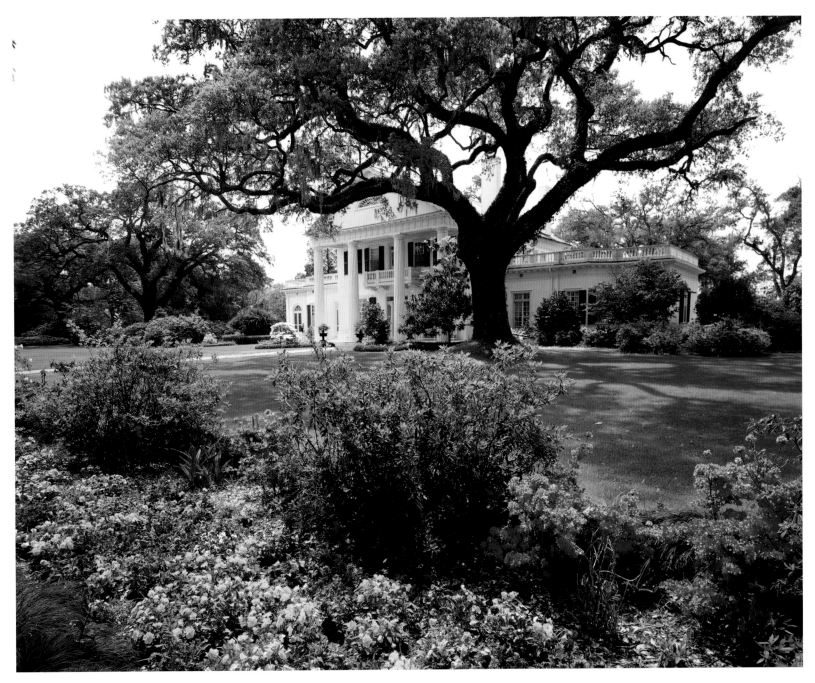

◄ Indian pink *(Silene virginica)* and cow vetch create a colorful mosaic.
▲ Located on the Cape Fear River, Orton Plantation and Gardens was founded in 1725. The plantation house is one of the finest examples of pure Colonial-style architecture. In colonial times rice was grown on the plantation as a cash crop, and the old rice fields are still visible.

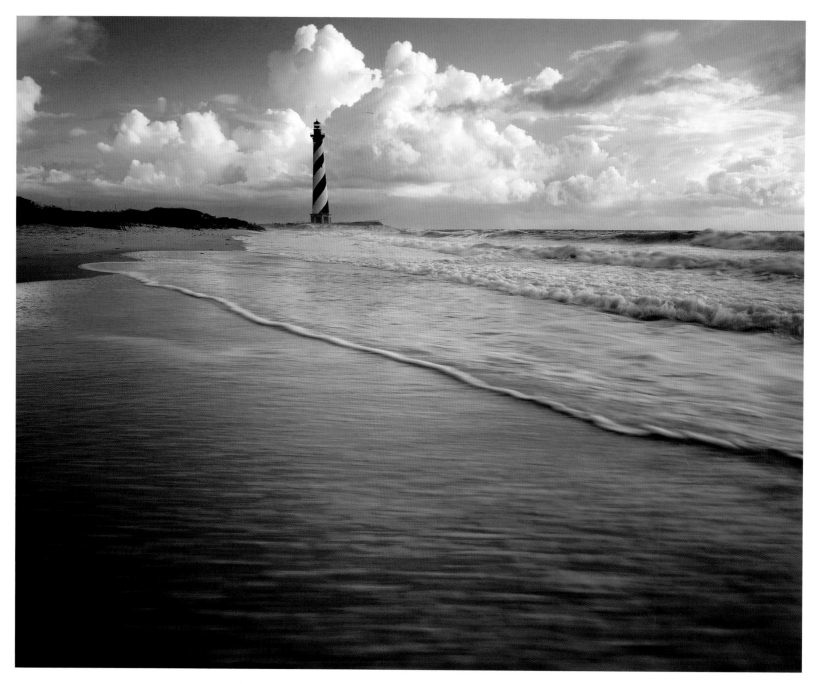

▲ The Cape Hatteras Lighthouse was built in 1870. Ninety-nine years before, Alexander Hamilton was en route to Boston from the West Indies when the ship he was sailing on, the *Thunderbolt*, caught fire and nearly sank. He called the area the "graveyard of the Atlantic," and petitioned Congress to construct a lighthouse at Cape Hatteras.
▶ In addition to glorious sunrises, the Cape Hatteras National Seashore boasts three lighthouses, Cape Hatteras, Bodie Island, and Ocracoke.

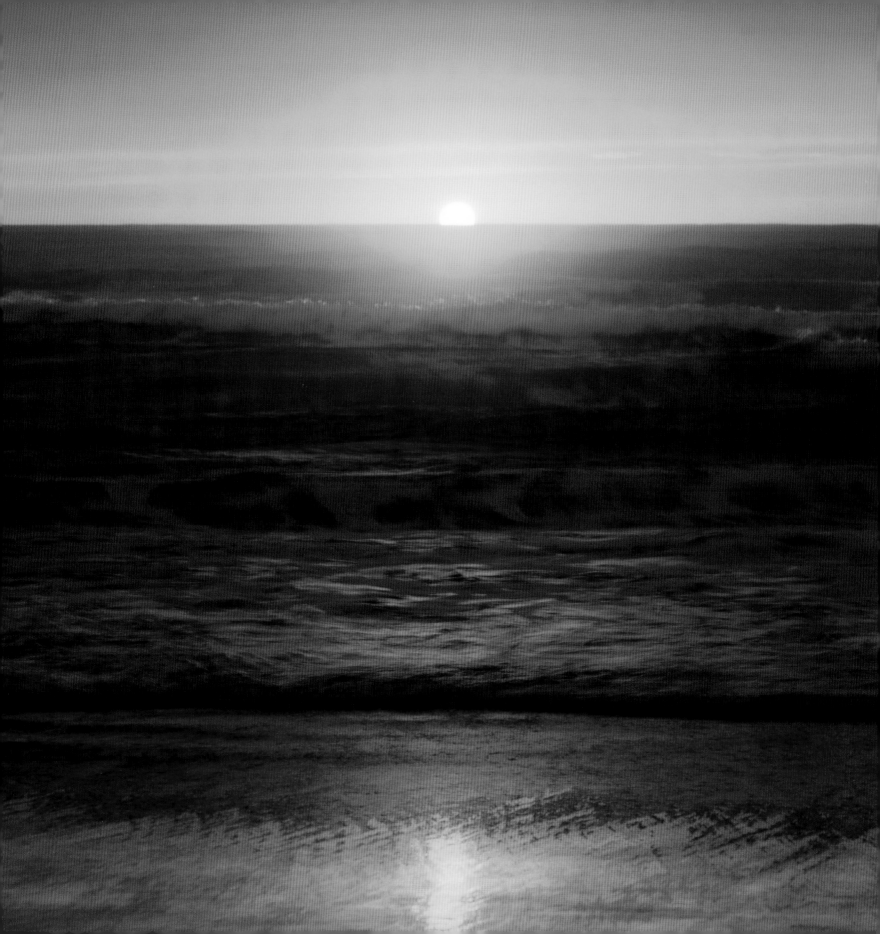

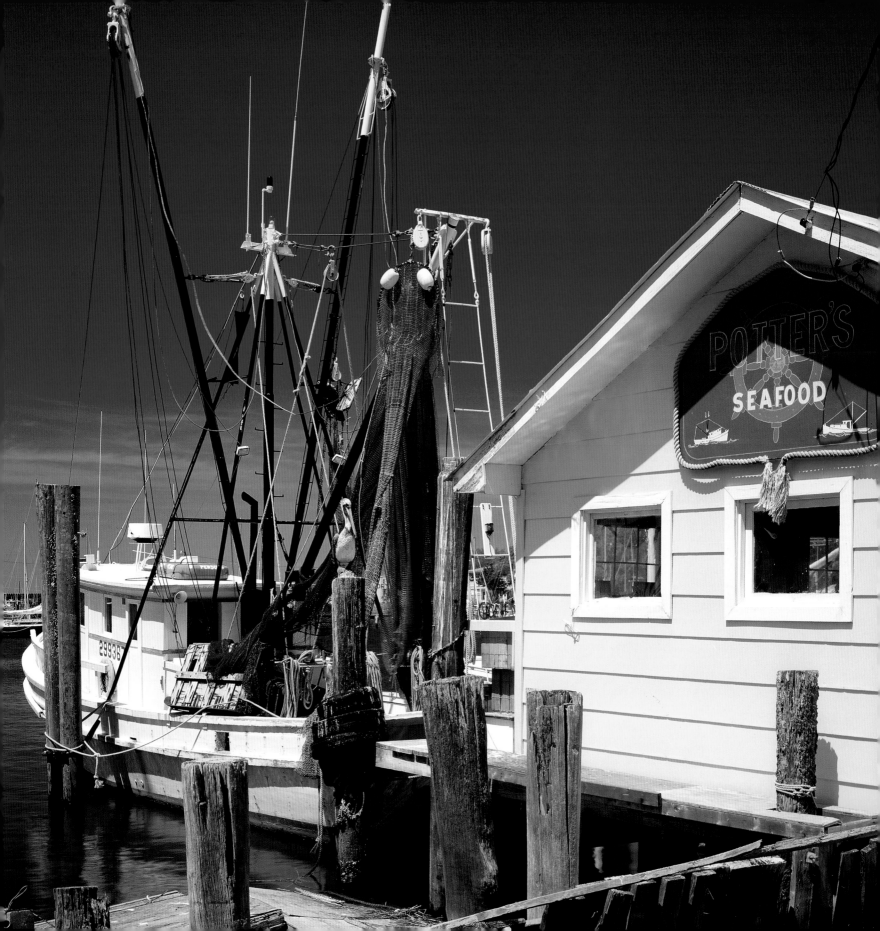

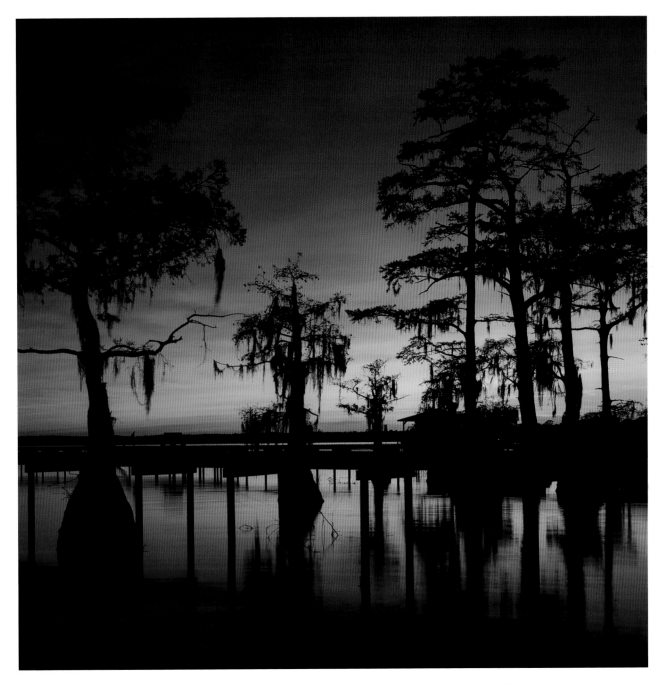

◄ Southport began in 1792. Earlier settlement in the state was hindered by the Outer Banks and huge sounds that prevented direct access to the ocean. The Cape Fear River, which flows into the Atlantic, was an exception.
▲ Lake Waccamaw is a water-filled Carolina bay. The water chemistry of Lake Waccamaw is neutral, which gives rise to aquatic endemism, making it the most biologically diverse lake in the state. Found in the lake are many rare species known only from Lake Waccamaw.

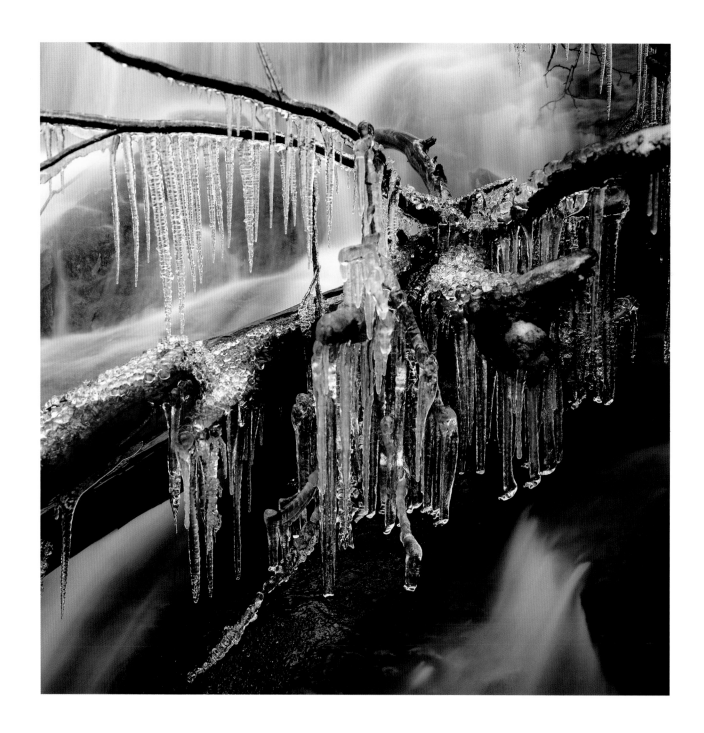

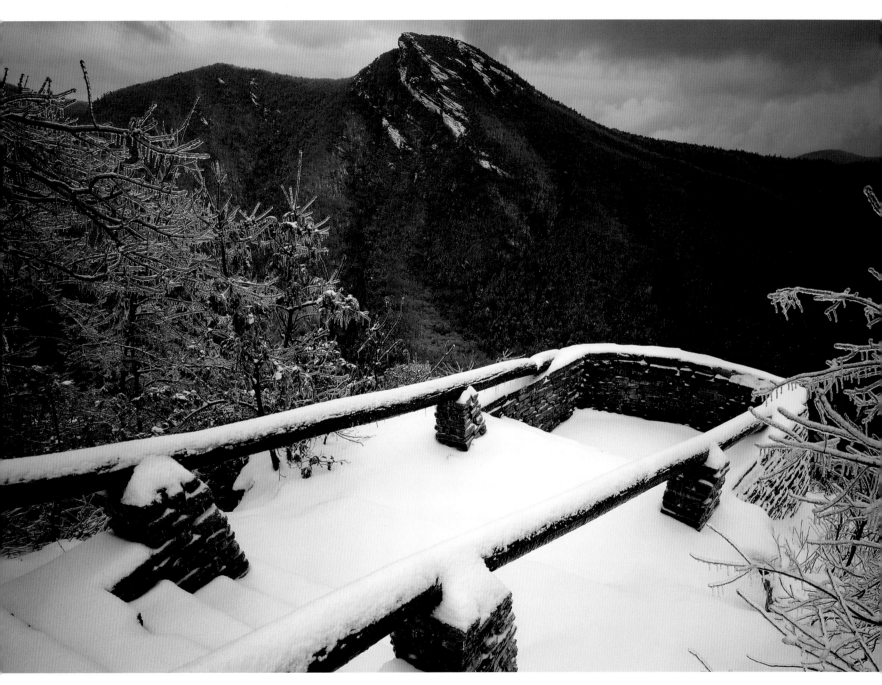

◄ Ice adorns a tree fallen across Walker Falls, in Pisgah National Forest.
▲ Wiseman's View was named for William Wiseman, who settled near
Linville Gorge in the eighteenth century. Visible across the gorge is the
rocky summit of 4,020-foot Hawksbill Mountain. From Wiseman's View
one can look north toward Babel Tower, east toward Hawksbill and Table
Mountains and the Piedmont beyond, or south to Shortoff Mountain.

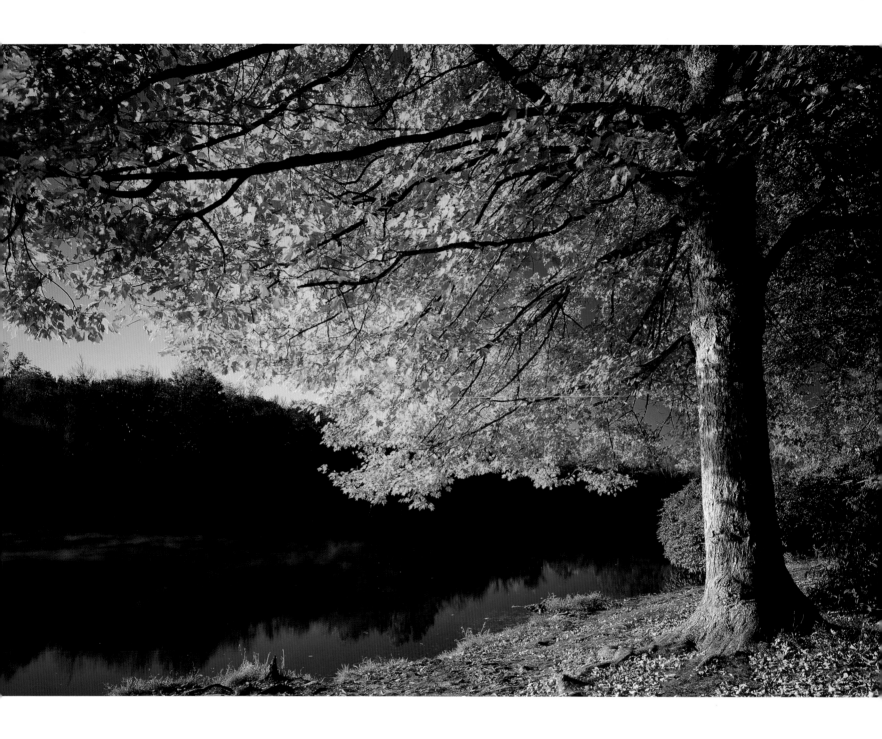

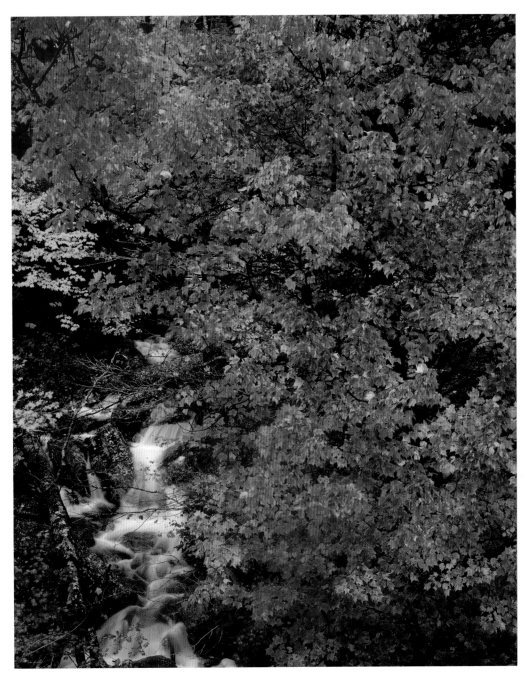

◀ A yellow maple in autumn glory overlooks Julian Price Memorial Park. The only lake bordering the parkway in North Carolina, Julian Price Lake is situated near milepost 296 on the Blue Ridge Parkway.

▲ Wilson Creek, surrounded by the brilliance of autumn, cascades down Grandfather Mountain. Henry Beston wrote in *The Outermost House*, "Nature is a part of our humanity, and without some awareness and experience of that divine mystery, man ceases to be man."

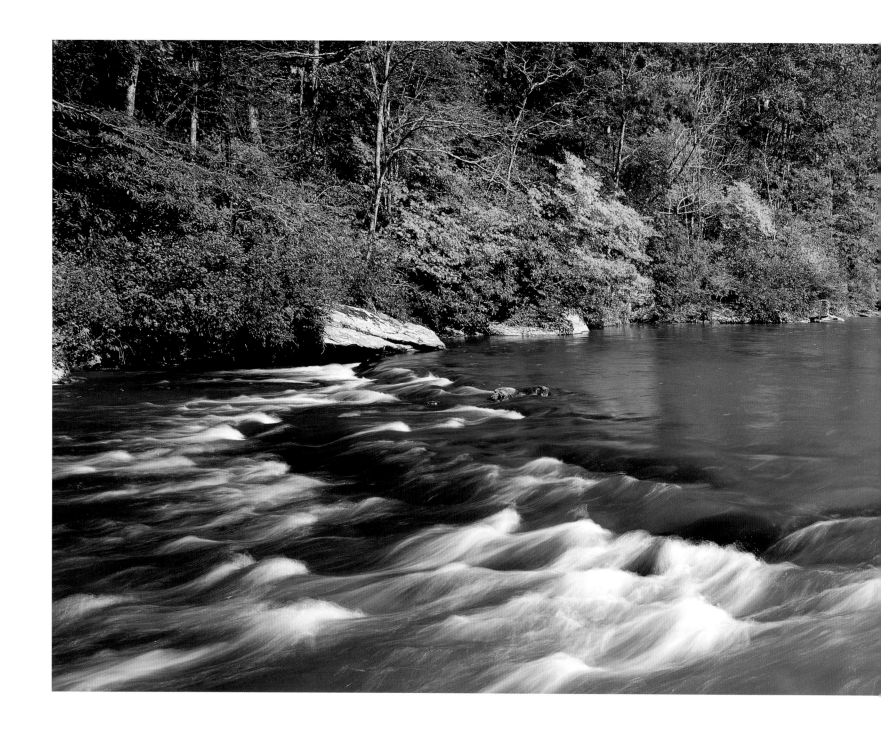

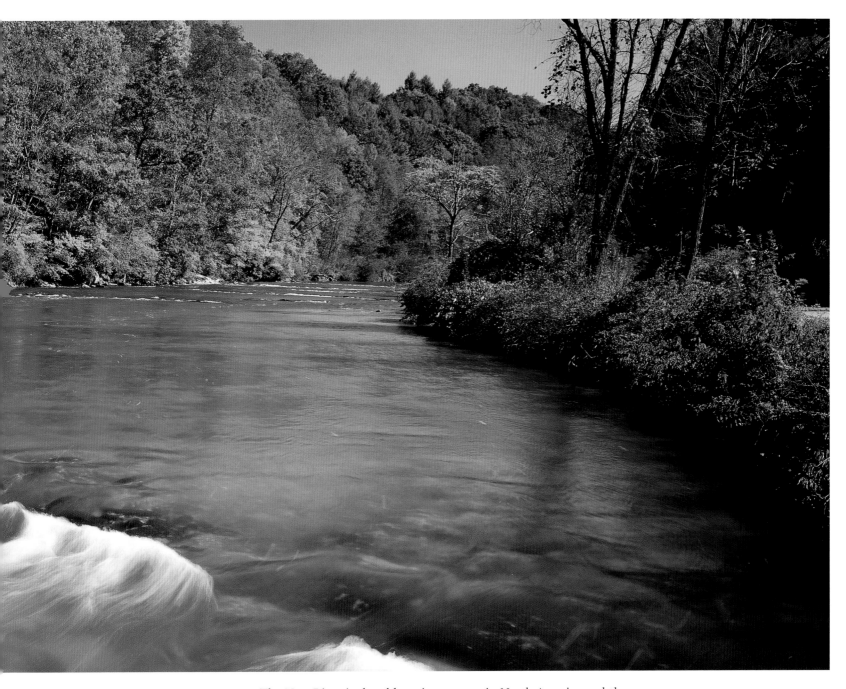

▲ The New River is the oldest river system in North America and the second in geologic age only to the Nile. A 26.5-mile stretch of the South Fork is designated a State and National Wild and Scenic River.

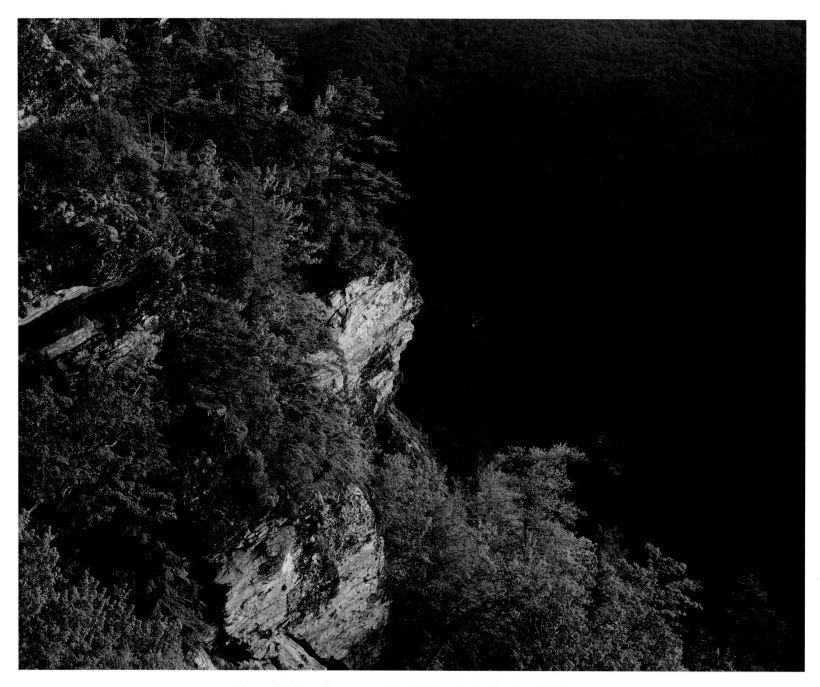

▲ Wiseman's View offers scenes of Linville River in Linville Gorge Wilderness. Among the roughest in the eastern U.S., the wilderness contains 11,400 acres. ▶ Pink and red poppies brighten a field in Buncombe County. The words of Euripedes seem fitting: "But that which has been born of earth, to earth returns; and that which sprouted from ethereal seed to heaven's vault goes back. So nothing dies of all that into being becomes, but each from each is parted and so takes another turn."

70

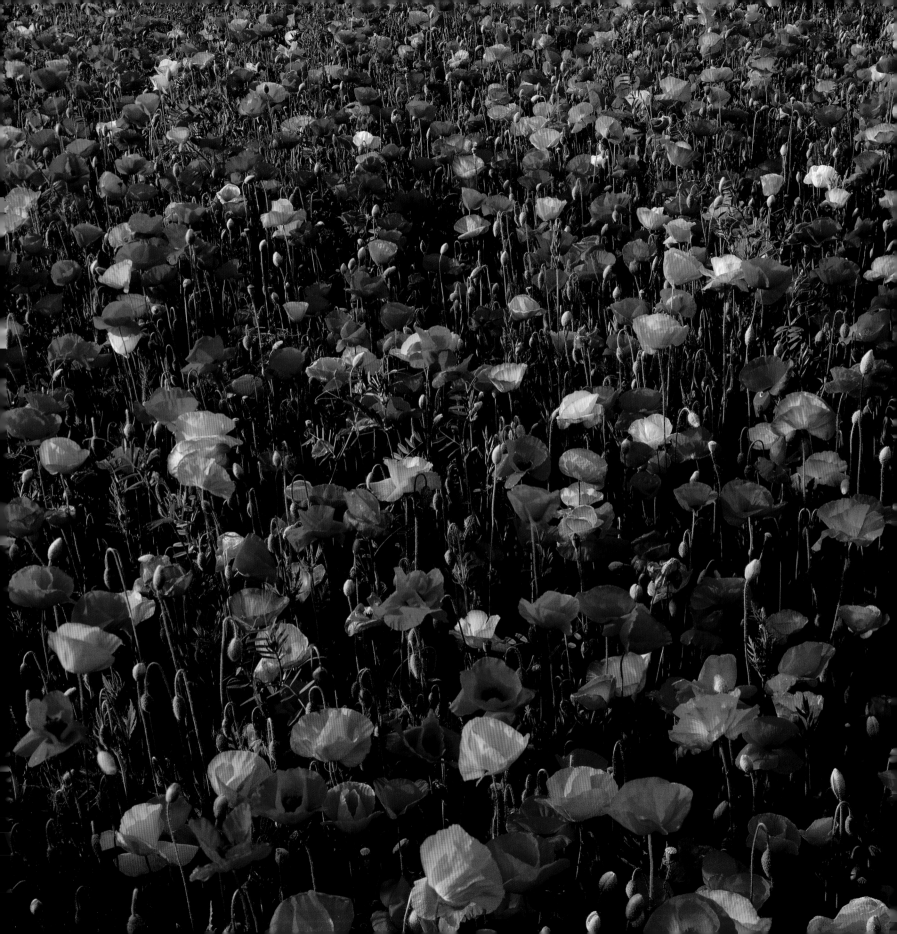

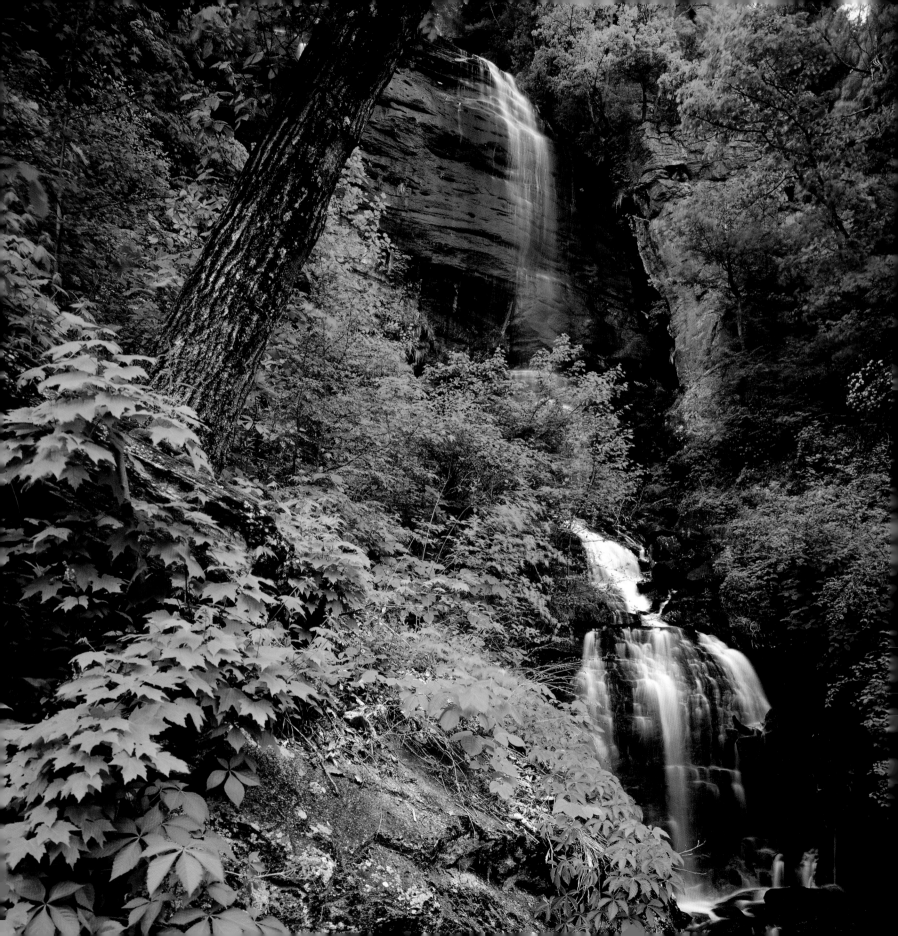

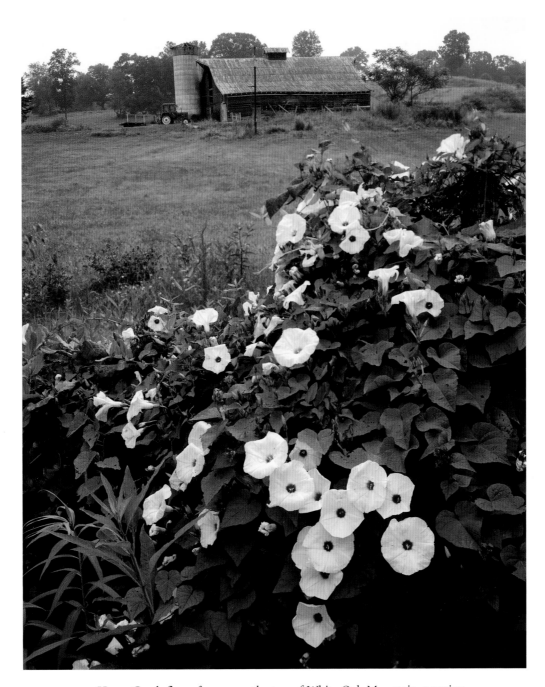

◄ Horse Creek flows from near the top of White Oak Mountain, pouring 150 feet down the Blue Ridge Escarpment to create Shunkawauken Falls.
▲ Farming remains important to North Carolina, but the agrarian life is disappearing as the state shifts to high-tech industries and banking.

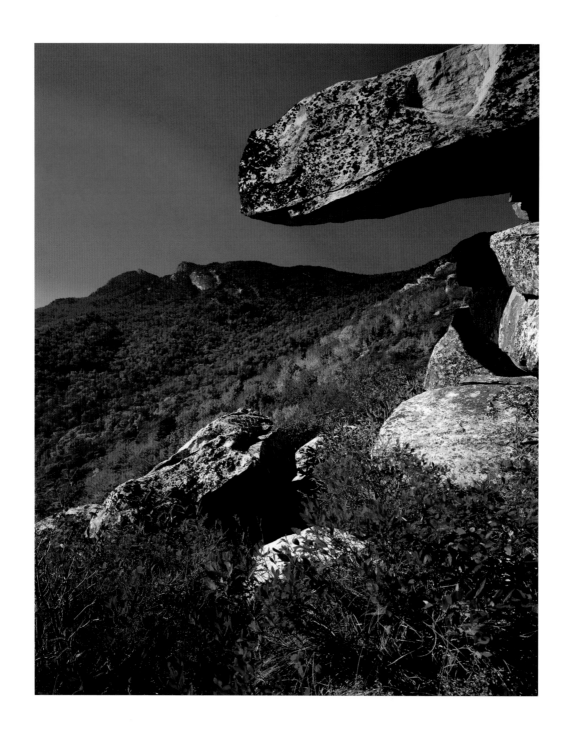

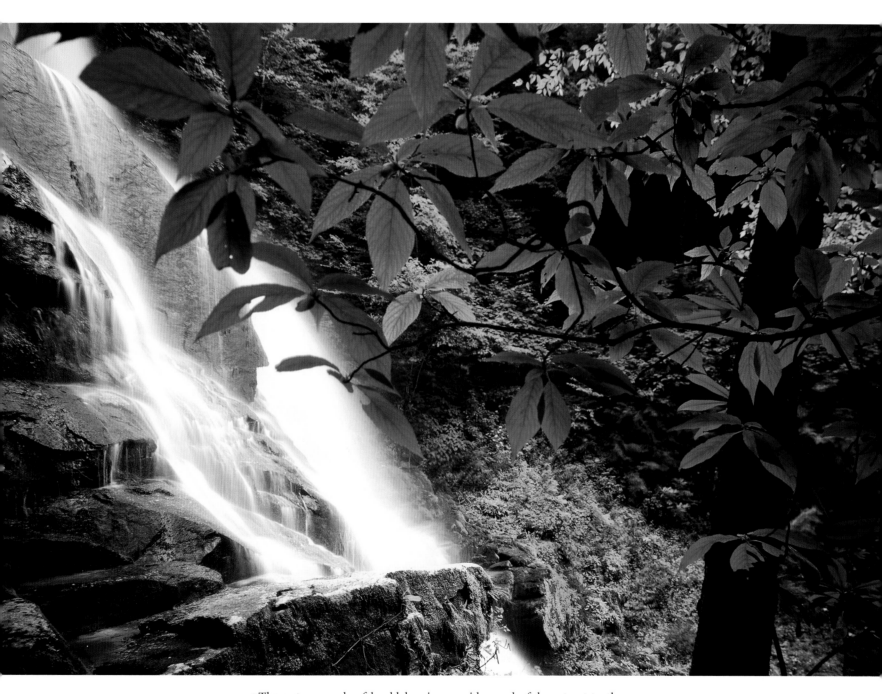

◄ The autumn reds of huckleberries provide a colorful contrast to the bold rock outcrops, showcasing Calloway Peak on Grandfather Mountain.

▲ Estatoe Falls, on Shoals Creek, apparently got its name from the Cherokee. William Gilmore Simms translates *estatoe* as "green bird" or "Carolina Parakeet People," referring to a tribal band that bore a standard decorated with feathers of this bird. *Tsiskua* and *itsey,* words that imply a grass-colored bird, may have been corrupted into "ishtatohe."

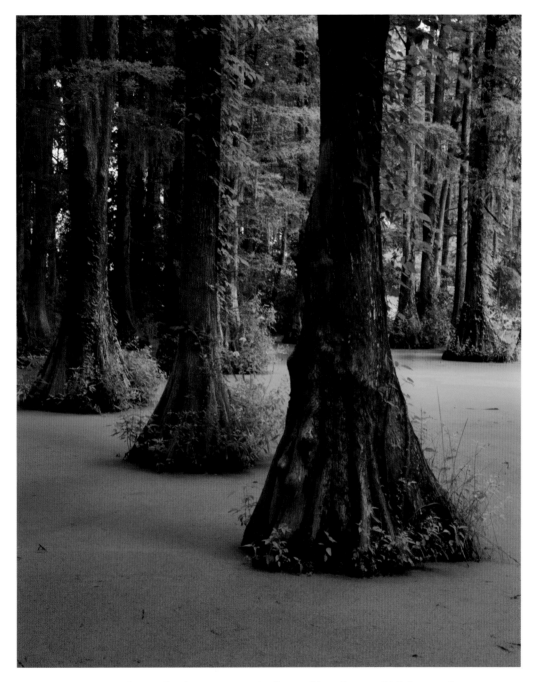

◄ Live oaks are the dominant tree in the maritime forest, which is severely threatened in North Carolina. These trees seldom grow more than fifty feet in height, but their sprawling branches may cover more than an acre, forming a canopy over the forest floor that can extend 160 feet from the trunk. ▲ Bald cypress trees accent Greenfield Lake in Wilmington. A natural lake that covers 125 acres within the city, it has a maximum depth of twelve feet.

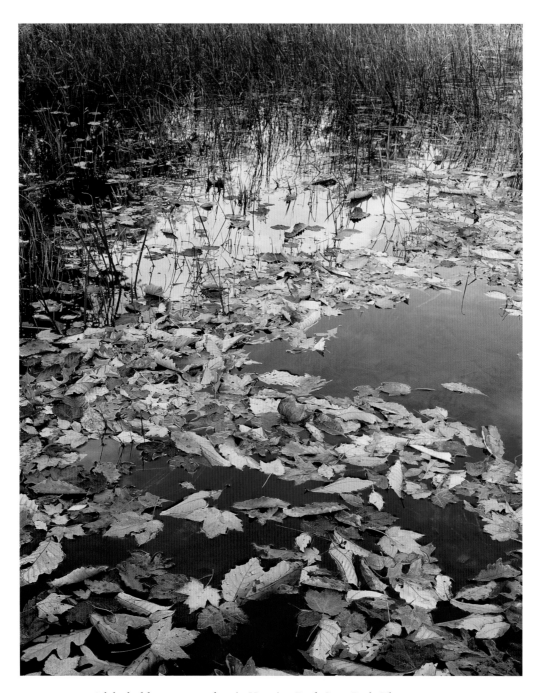

▲ A lake holds autumn colors in Hanging Rock State Park. Thoreau wrote, "A lake is the landscape's most beautiful and expressive feature. It is the earth's eye, looking into which the beholder measures the depth of his own nature."

▶ The rare quartzite conglomerate rock at the crest of Grandfather Mountain is fractured with serrated peaks, large boulders, and huge rocky outcrops. The rocks' mineral composition is varied, giving rise to rich plant diversity.

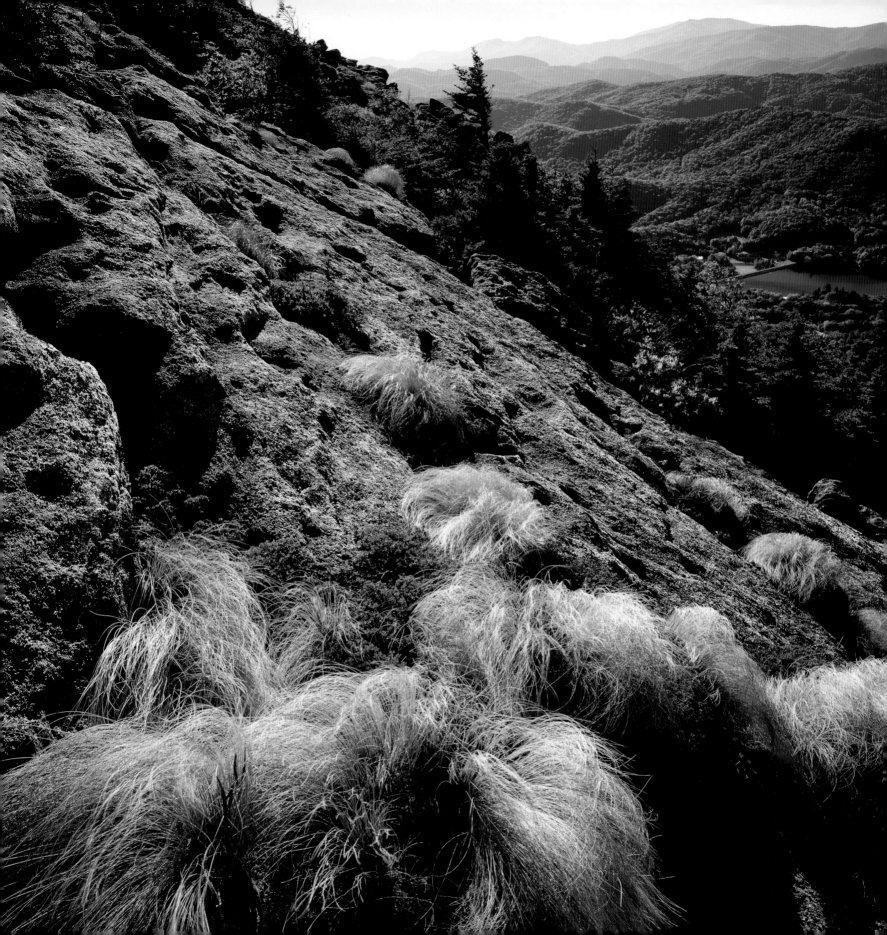

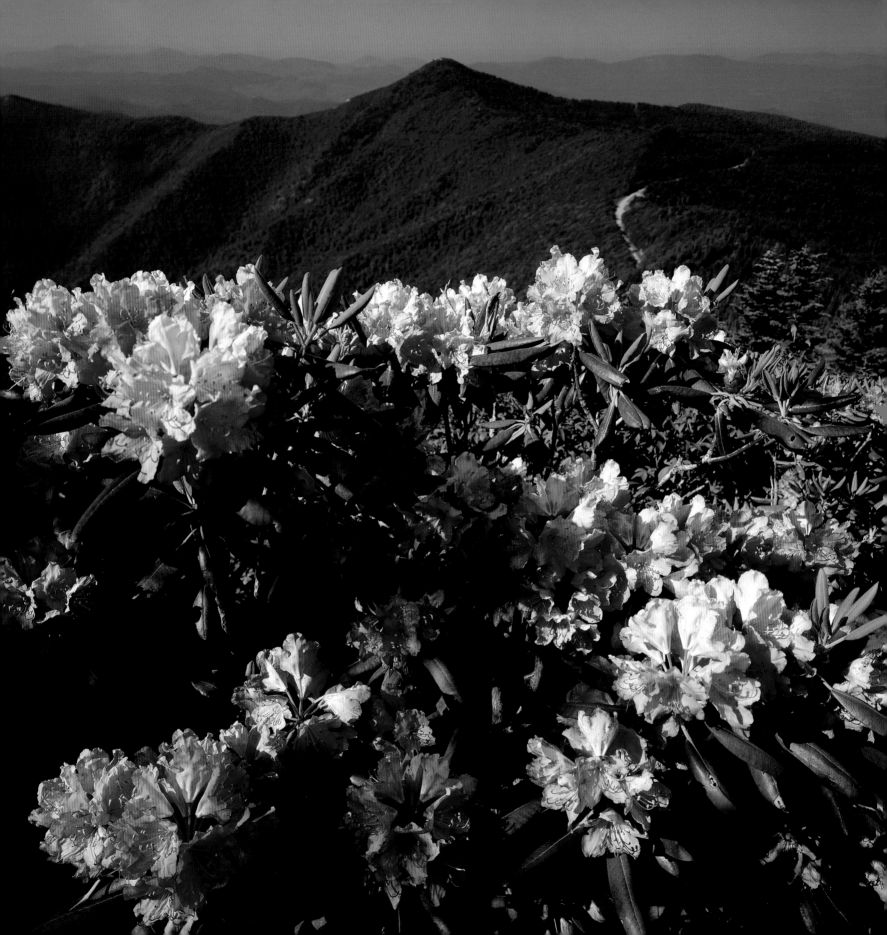

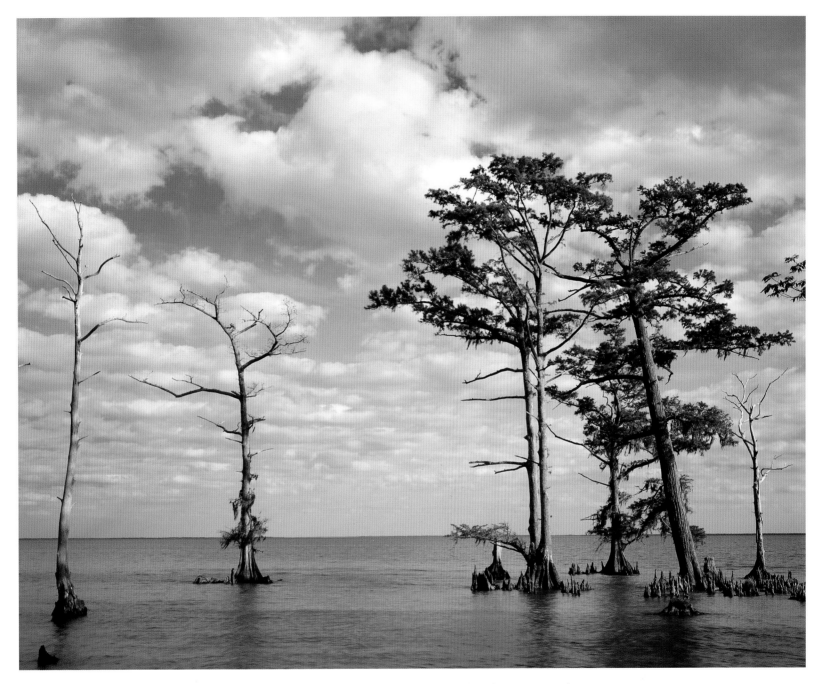

◄ The climb up Potato Knob is rugged, a tough mile or more to the top, but the panoramas are worth the effort. Views of the Pinnacle and the Blue Ridge Parkway open to the eye at the crest of the first ridge. And rhododendron clings tenaciously to the mountain's rocky crags all along the trail.

▲ Fifty-two-mile-long Albemarle Sound is from five to fourteen miles wide.

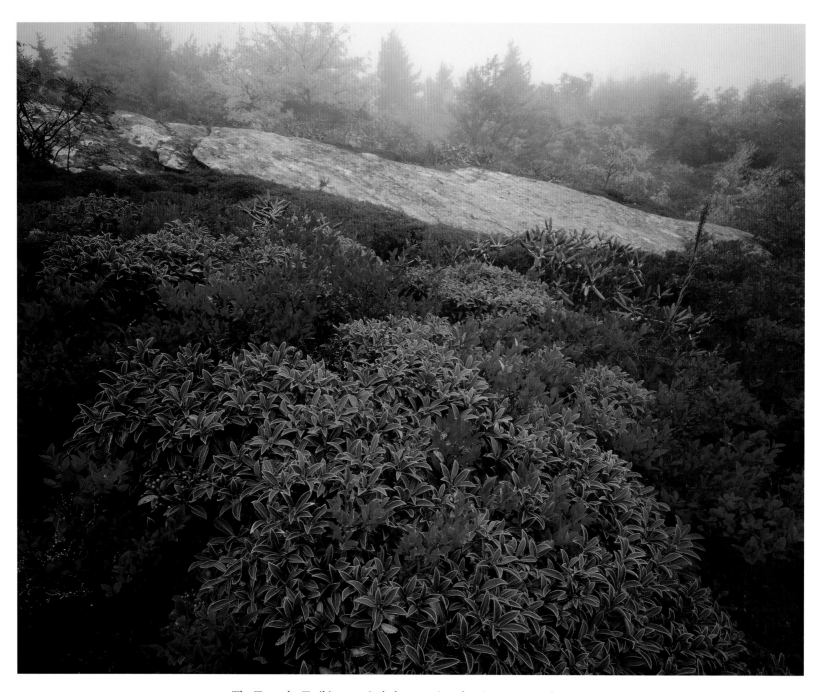

▲ The Tanawha Trail is a magical place anytime, but in autumn colors over-whelm the vision from every direction: huckleberries, beech, hickories, oaks, sourwood, fire cherry, sassafras, yellow birch, paper birch, buckeye, serviceberry, silverbell, mountain ash, and sugar, yellow, and red maples.

▶ In Transylvania County, Dunn's Creek is a pristine mountain stream—the first creek the photographer ever hiked.

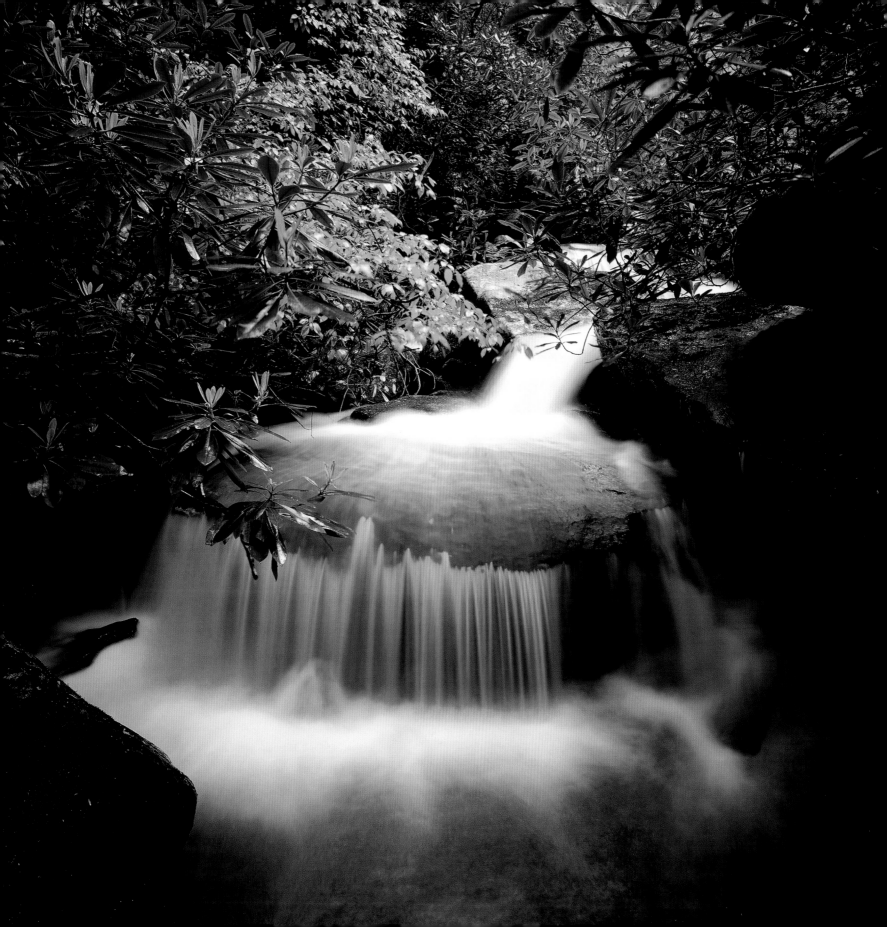

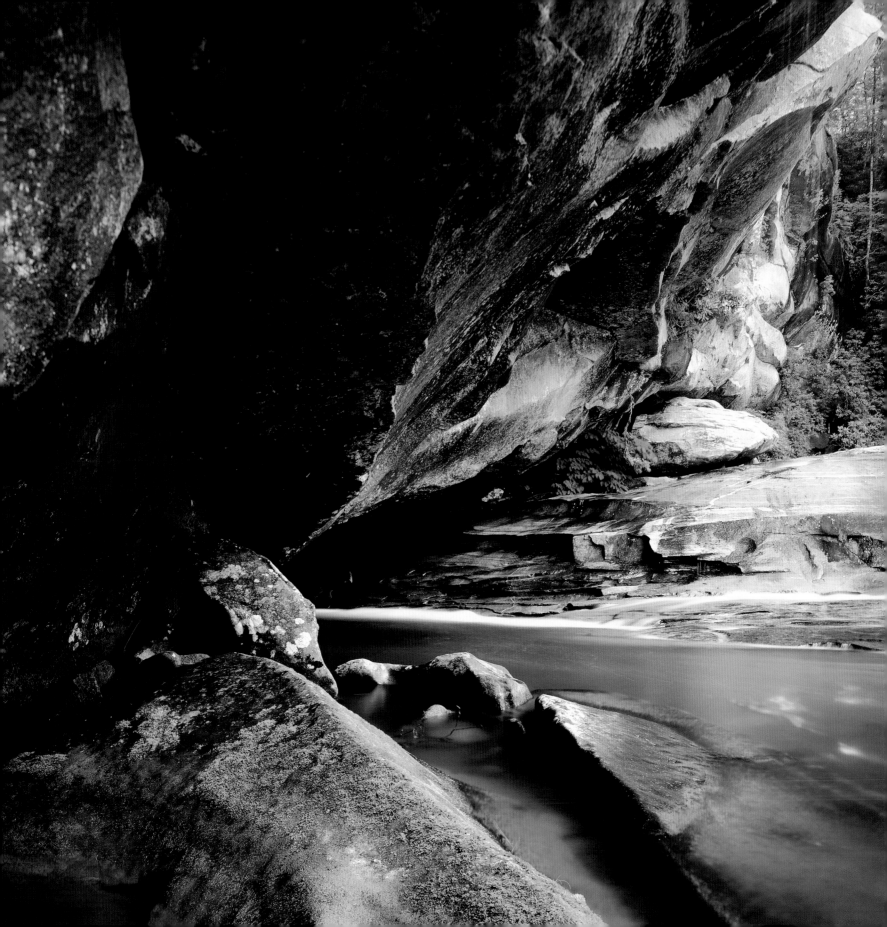

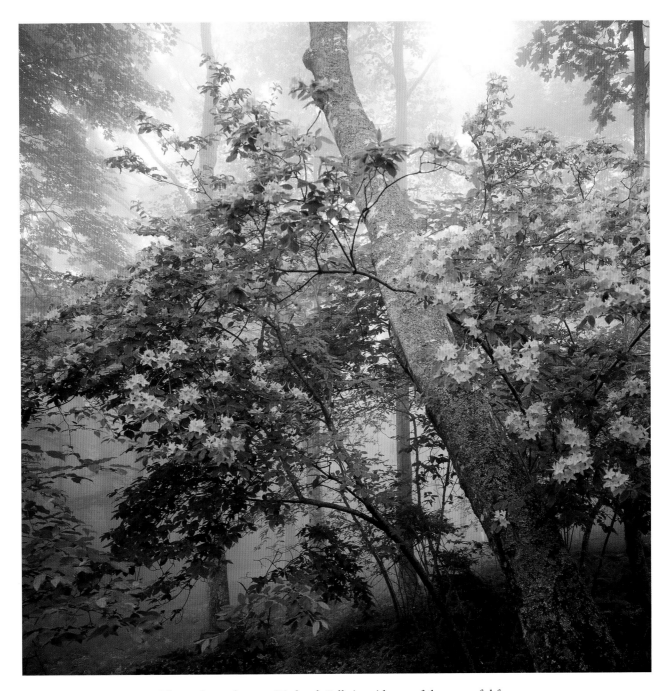

◄ The rock overhang at Birdrock Falls is evidence of the powerful forces that shaped the southern Appalachians, which are among the oldest mountains on earth. Purple martins once nested on these cliffs. ▲ William Bartram, who traveled through the southern Appalachians in the late 1700s, wrote in his journal that the flame azalea is "the most . . . brilliant flowering shrub yet known." Its blossoms grace the Piedmont and mountains of North Carolina from April through July, depending on the elevation.

85

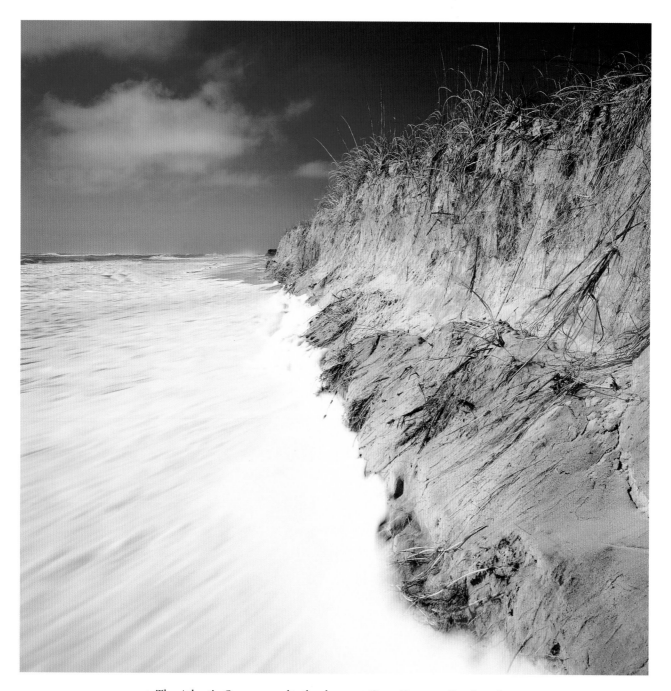

▲ The Atlantic Ocean assaults the dunes at Cape Hatteras. Erosion along the beach is a constant problem all along the Outer Banks, since these barrier islands are perched right on the edge of the continental trough.

▶ The seventy-five-foot Ocracoke Lighthouse, built in 1823, cost $11,359.35. Ocracoke is the second-oldest lighthouse still in operation in America.

▶ ▶ Oregon Inlet, along with Hatteras Inlet, was opened by a storm in 1846, creating new passages from the Atlantic into Pamlico Sound.

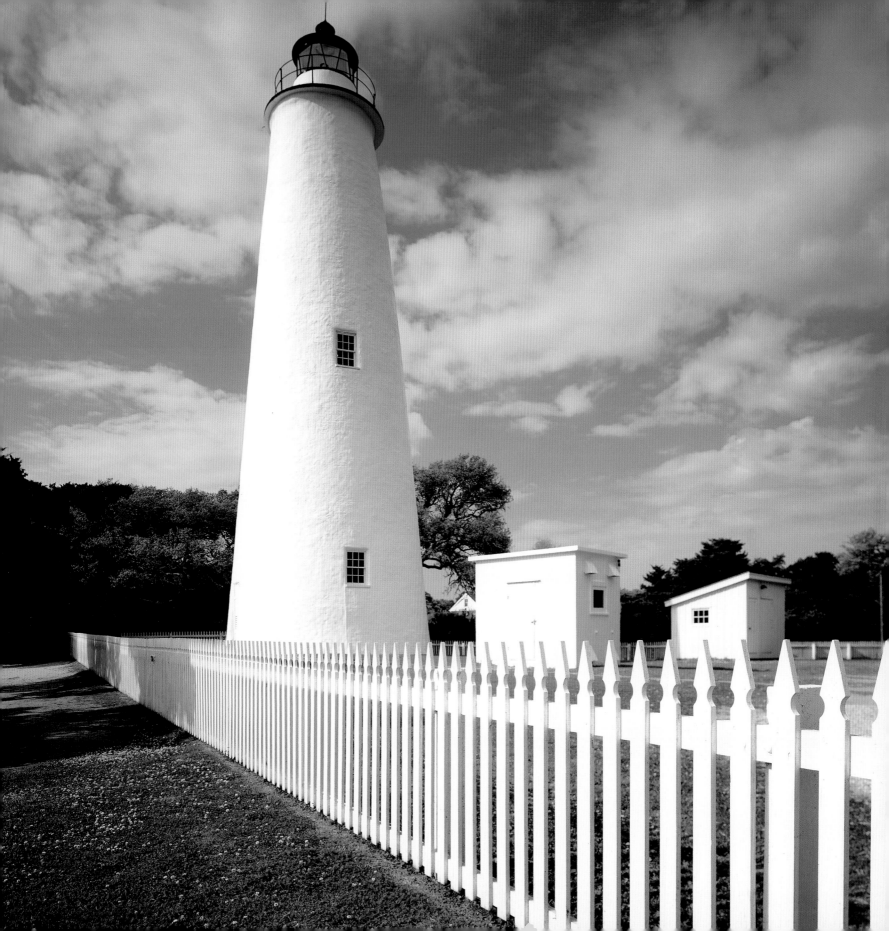

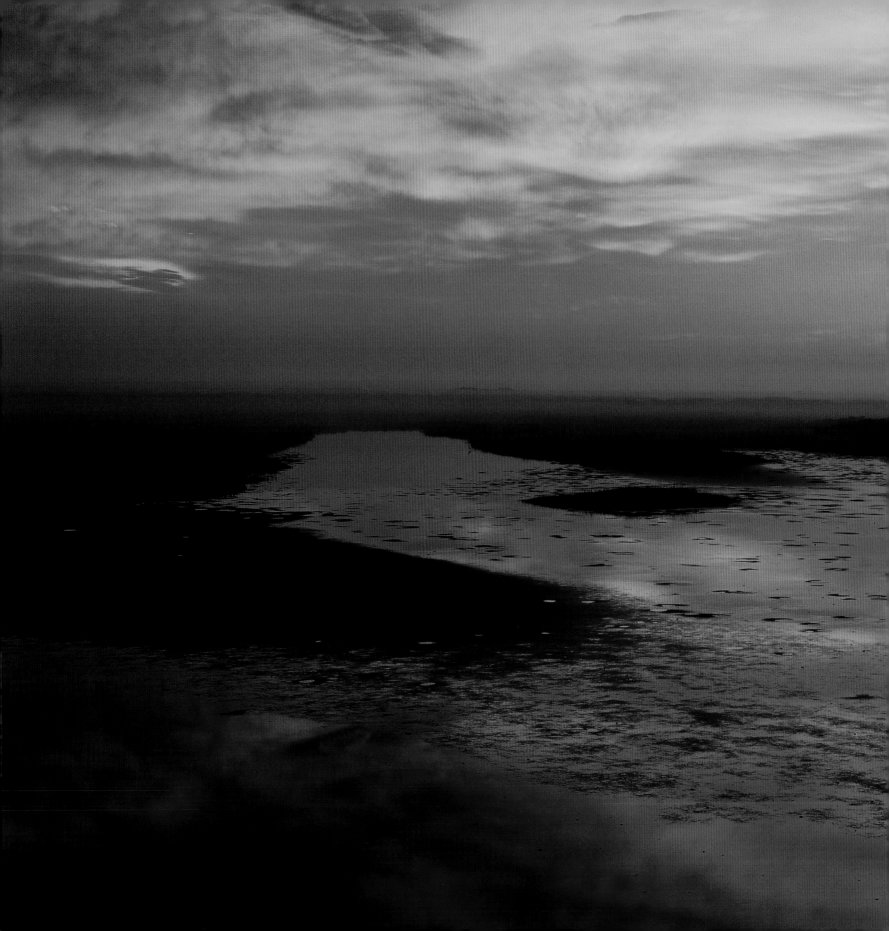

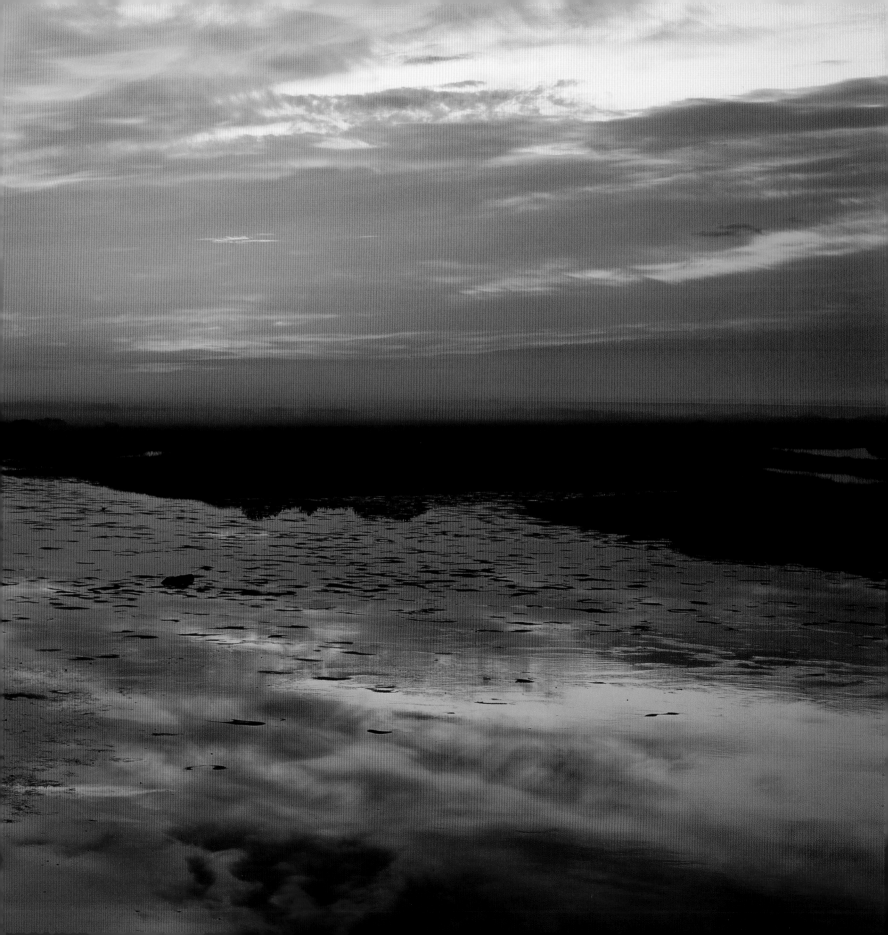

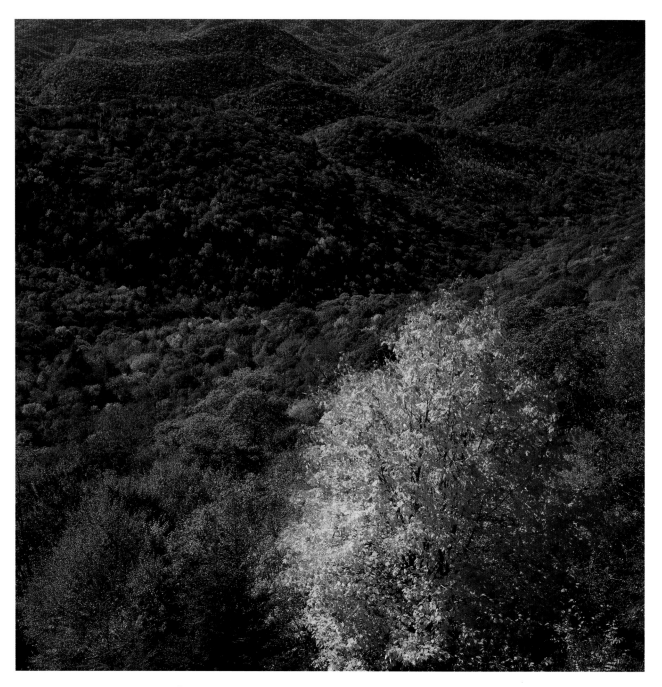

▲ A yellow maple explodes with color. As John Muir so beautifully surmised, "The forests of America, however slighted by man, must have been a great delight to God, for they were the best he ever planted."
▶ Mountain ash and red spruce make up 95 percent of the forest canopy above 6,000 feet in the southern Appalachians. Clingman's Dome, at 6,643 feet, is the highest peak in the Great Smoky Mountains.

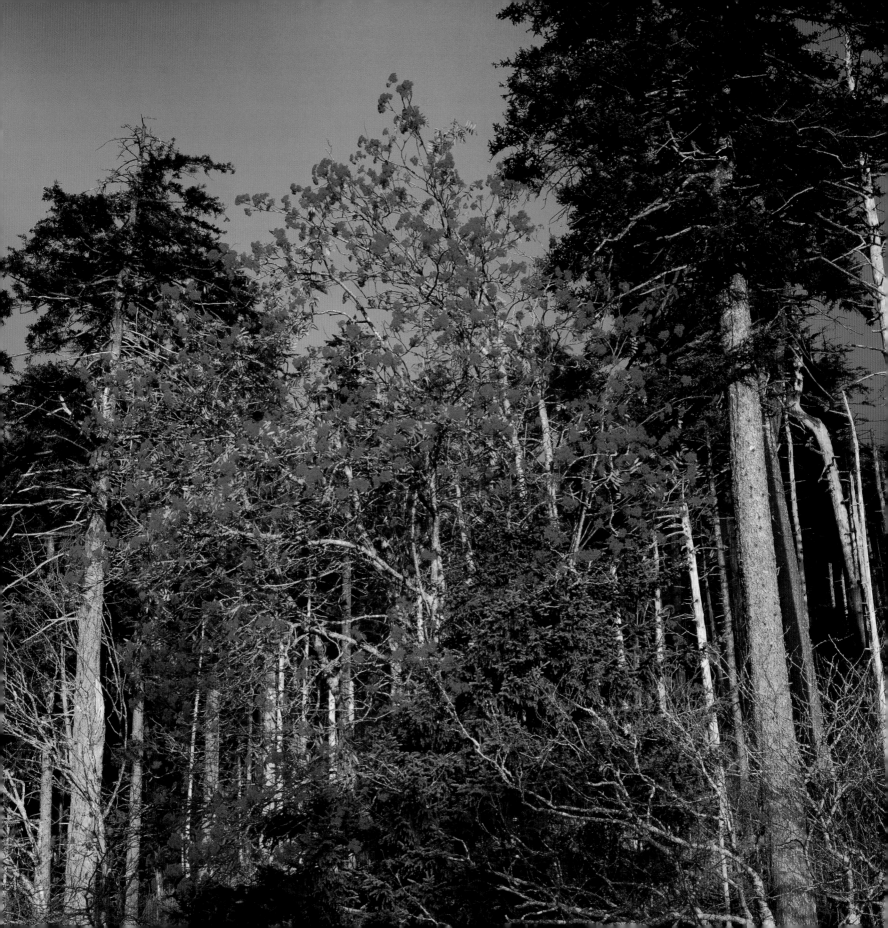

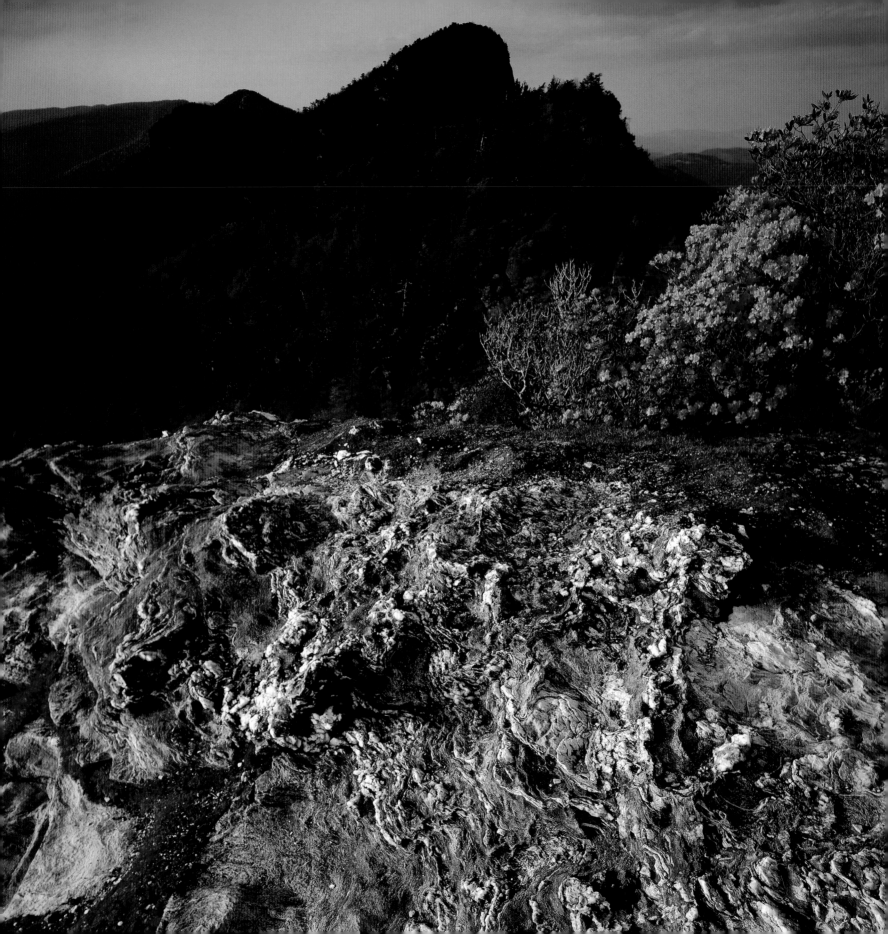

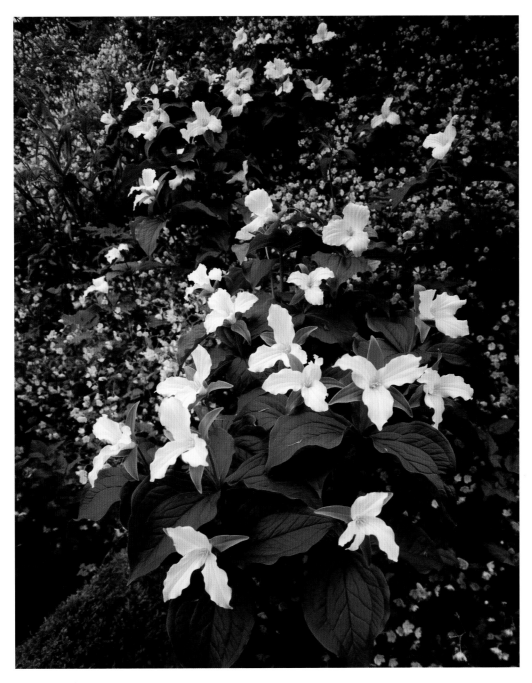

◀ Cliffs of the Chimneys and punctatum give way to Table Rock in Linville Gorge Wilderness. "Punctatum" is another name for Carolina rhododendron.

▲ Large-flowered trillium *(Trillium grandiflorum)* are found throughout the mountains, but fringed phacelia *(Phacelia fimbriata)* is seen in only four mountain counties. Large-flowered trillium, fringed phacelia, yellow trillium, trout lily, wind anemone, spring beauty, jack-in-the-pulpit, and hepatica carpet acres of woodlands in the Smokies with brilliant color.

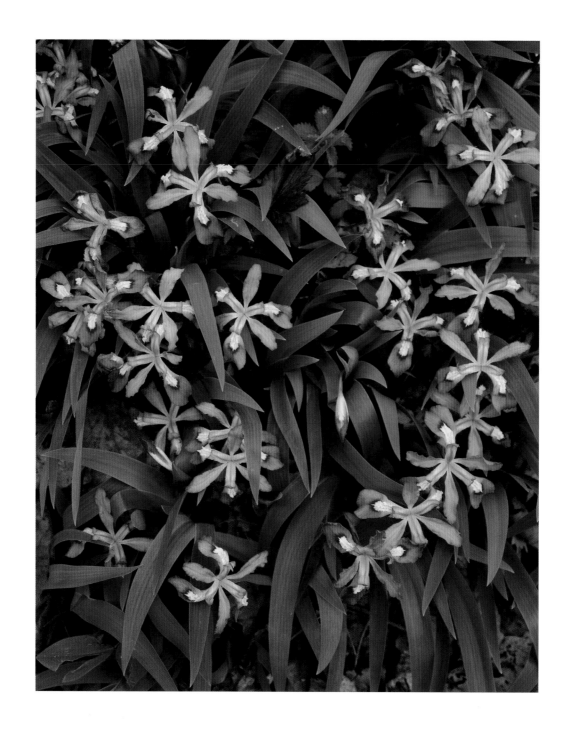

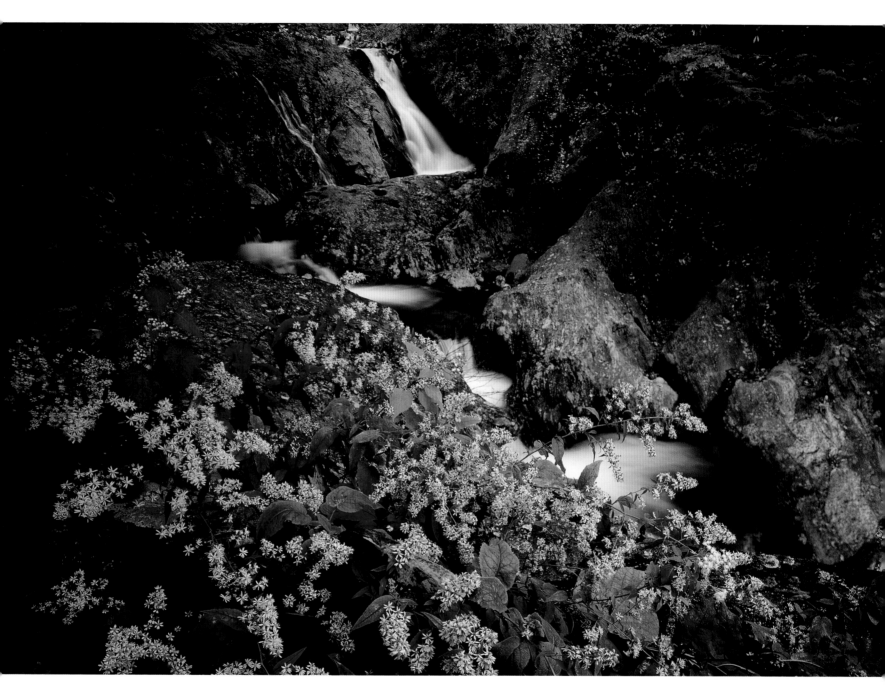

◄ Crested dwarf iris *(Iris cristata)* like rich woods in the mountains and Piedmont. Their beautiful flowers sprinkle the russet woodlands with splashes of blue lavender in April and May. The genus was named for the goddess Iris, the personification of the rainbow in Greek mythology.
▲ Asters brighten the banks of the West Fork of the Pigeon River. Asters, along with the green-headed coneflower, closed gentian, and grass of parnassus, bloom in late summer and early autumn.

95

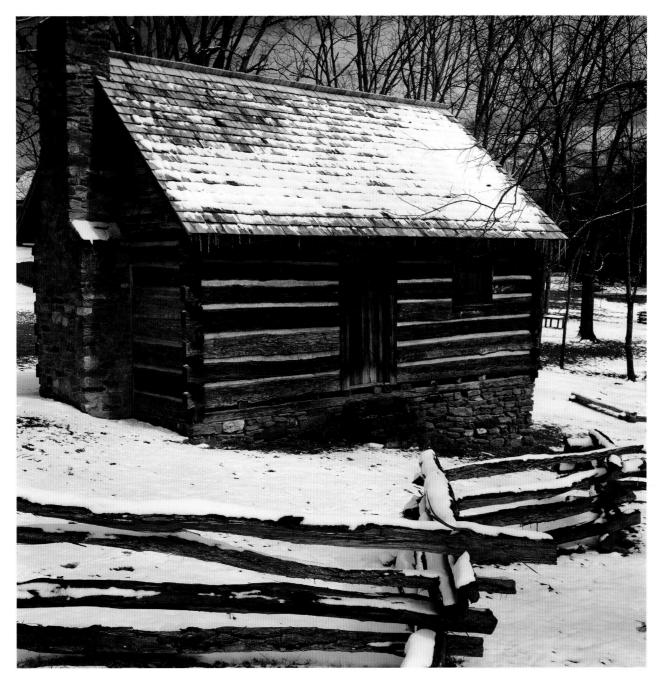

◄ An old tobacco barn sports fall decorations. The story is told that Indians once surrounded Daniel Boone in a tobacco barn. To escape, Boone pulled down racks of curing tobacco on the Indians. By the time they got through wiping the tobacco dust from their eyes, Boone was gone.
▲ North Carolina's War Governor, Zebulon Baird Vance, was born here in 1830. He became governor, then U.S. senator, but resigned as war began. Later, he again become senator, a position he retained until his death in 1894.

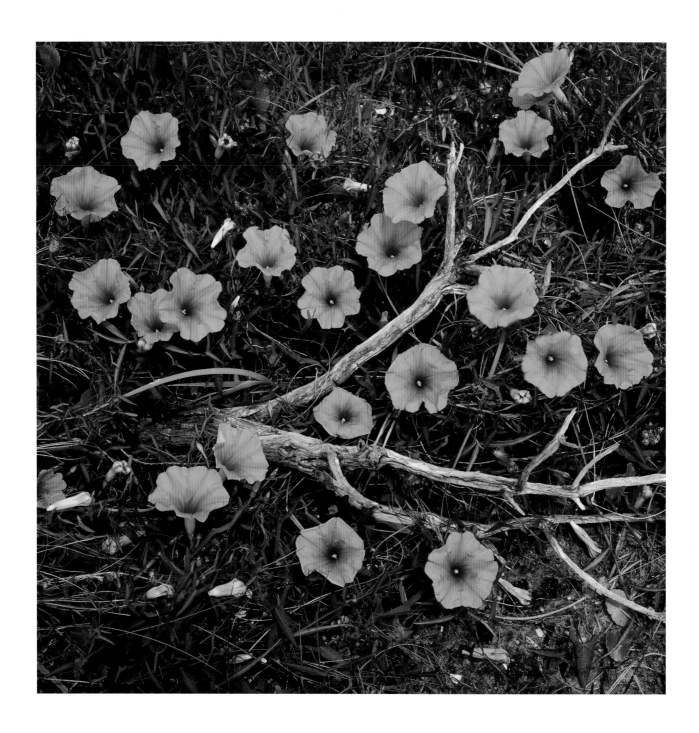

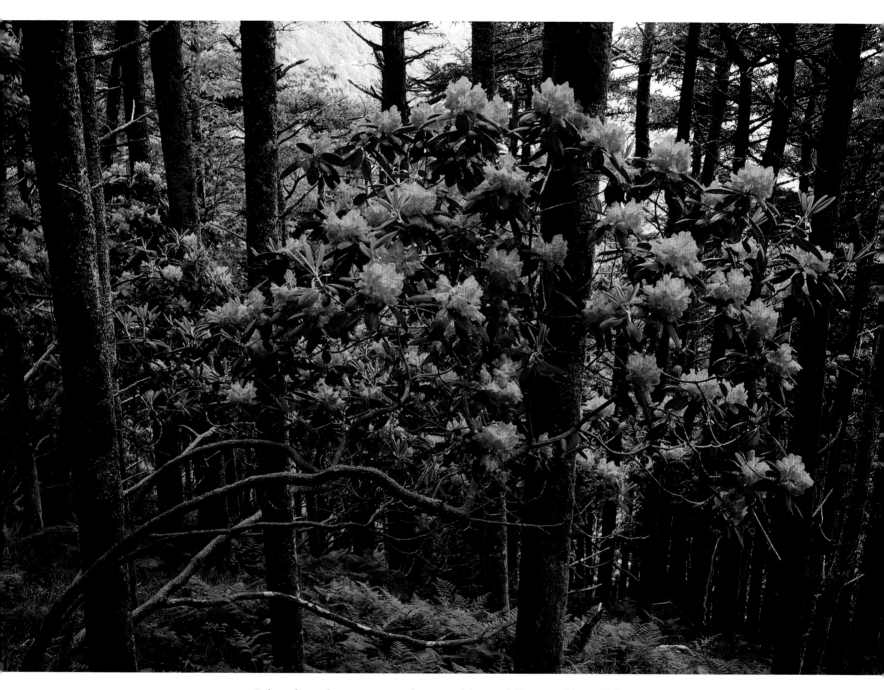

◄ It has always been a mystery how anything as delicate and beautiful as a morning glory survives in the sand dunes of the Outer Banks.
▲ Catawba rhododendron flourishes in wet woodlands and bogs and on moist mountains. It ranges from West Virginia and Virginia south along the Appalachian Mountains to northern Alabama and Georgia.
►► The Haw River was called the Hau by John Lawson in a survey of 1709. The name's origin is in question, coming perhaps from the Sissipahau Indians, or from the Hawthorn bush.

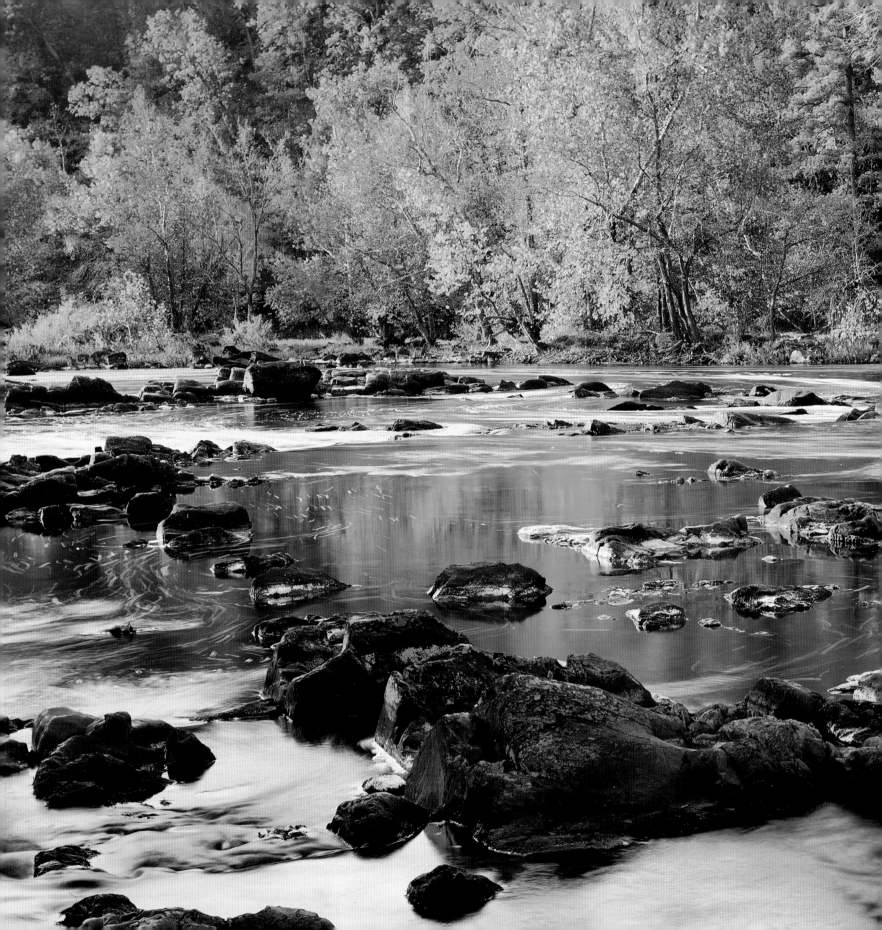

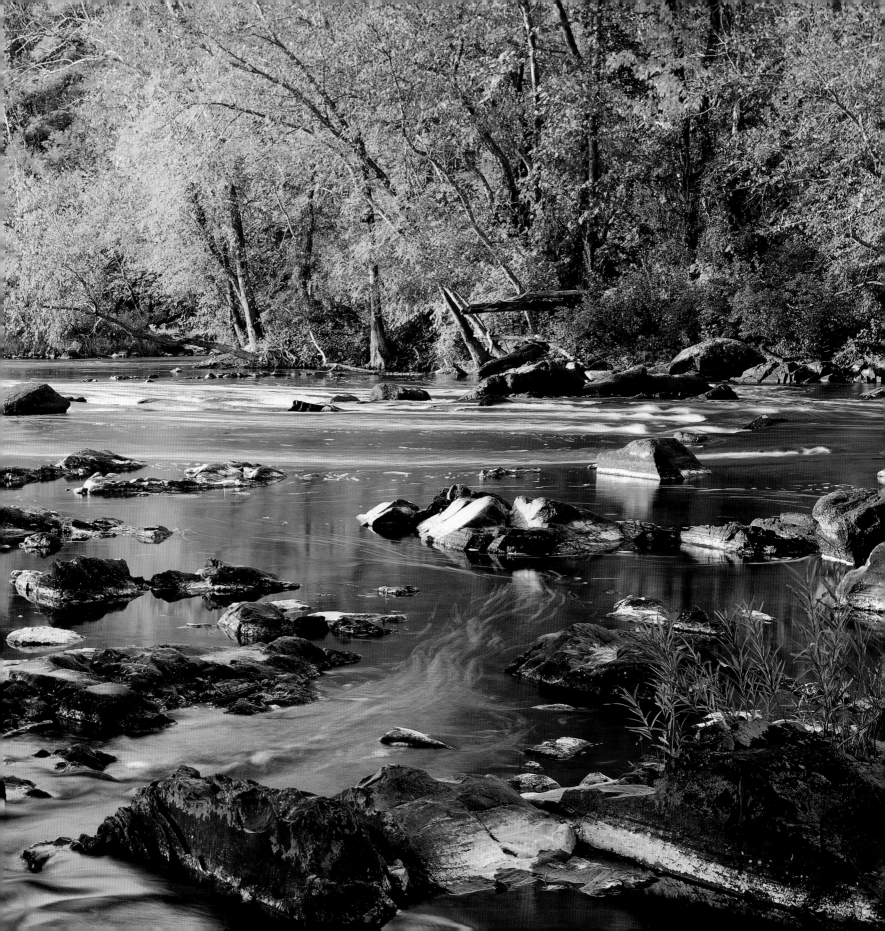

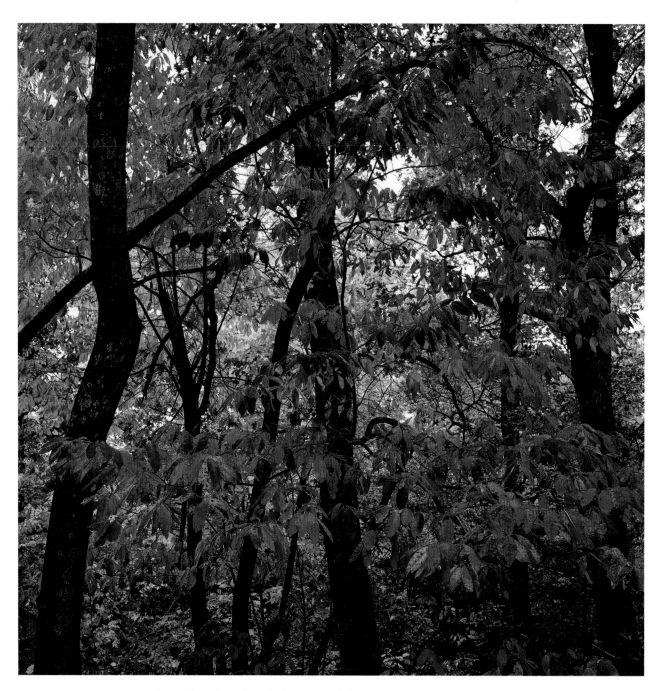

▲ More than three hundred species of flora grow in Hanging Rock State Park. Among them are rhododendron, mountain laurel, flame azalea, galax, turkey's beard, pink lady's slipper, Indian pink, and bird's-foot violet.

▶ Grandfather Mountain reaches the highest elevation of the Blue Ridge. Calloway Peak, the summit of the mountain, rises to 5,964 feet.

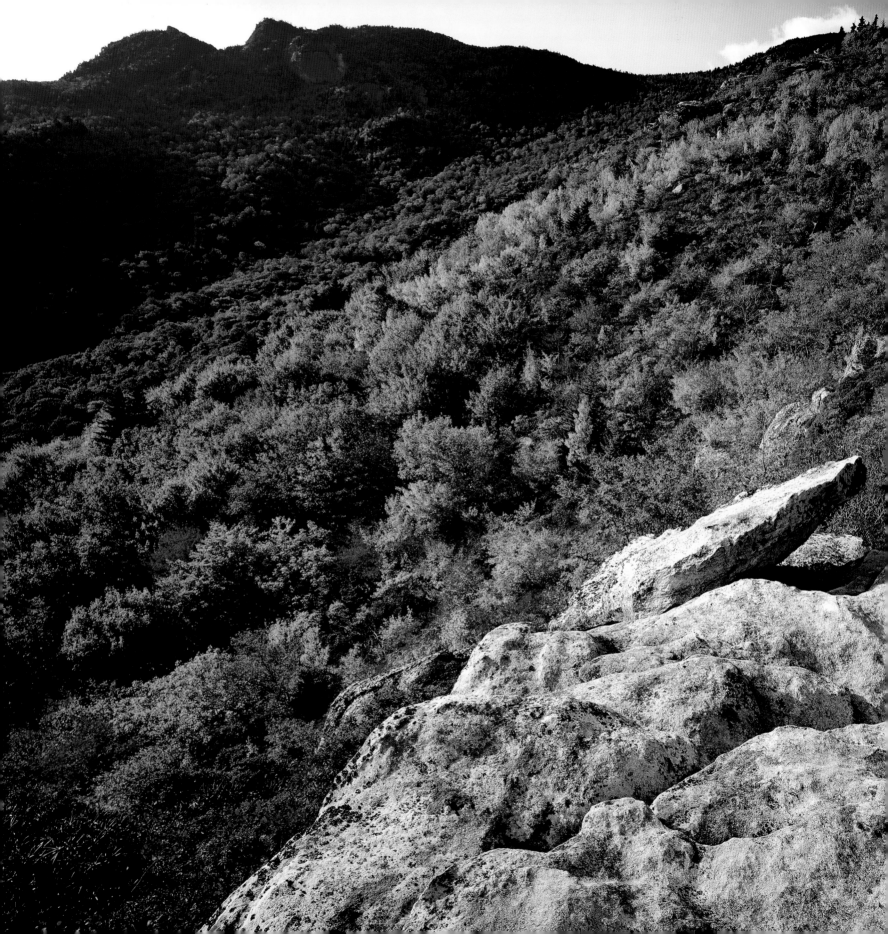

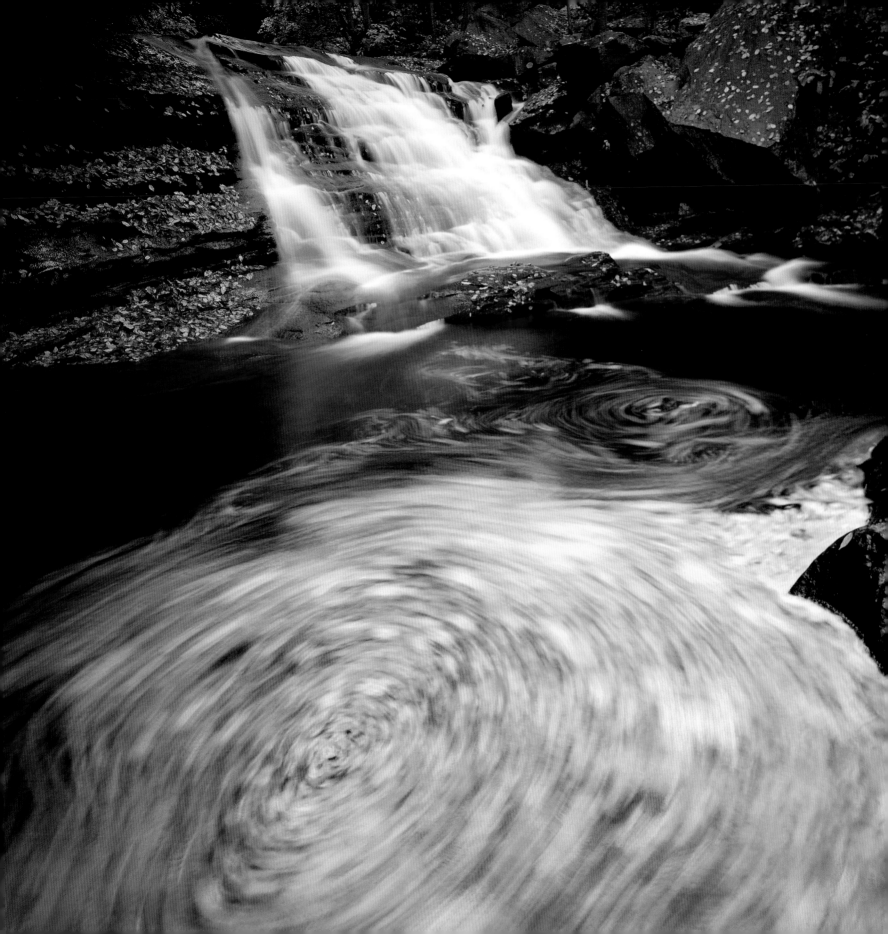

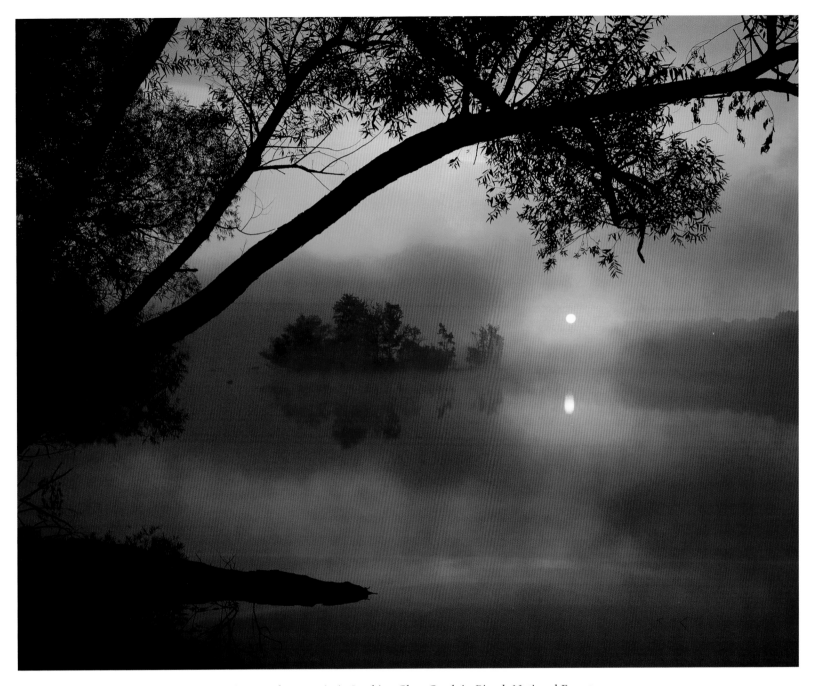

◄ Autumn leaves spin in Looking Glass Creek in Pisgah National Forest.
▲ Kerr Lake, formed in 1952 by the damming of the Roanoke River, is also fed by the Dan River, Nutbush Creek, and Island Creek. It is named for North Carolina Congressman John H. Kerr, 1873–1958.

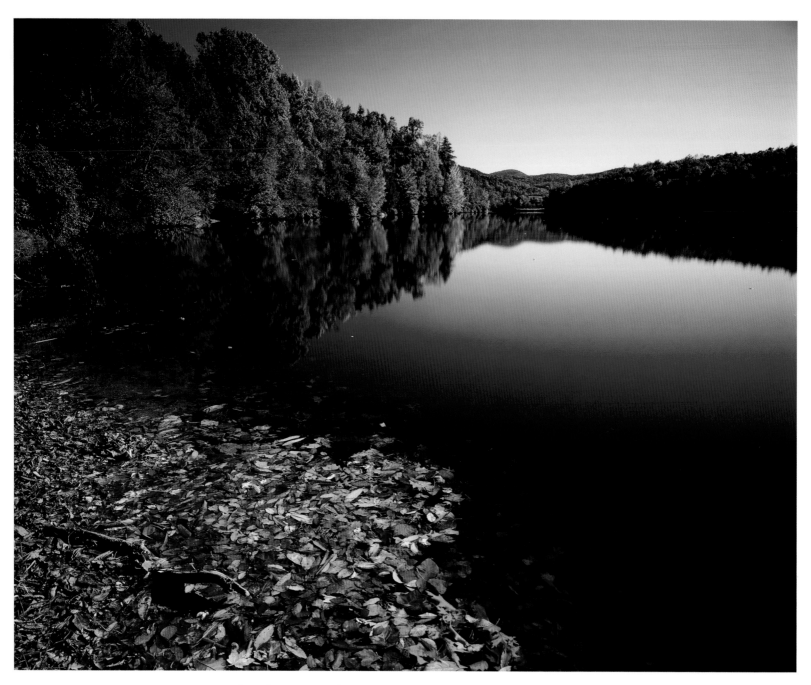

▲ The Julian Price wetlands embrace bogs, now rare in the mountains. These habitats support shrubs, marsh and sphagnum moss, and hummocks with red spruce, hemlock, and yellow birch. Julian Price once intended to develop a resort here, but did not accomplish his plan. After his death in 1946, the 4,344-acre parcel was given to the National Park Service.
▶ Fire cherry brightens the Davidson River in Pisgah National Forest.

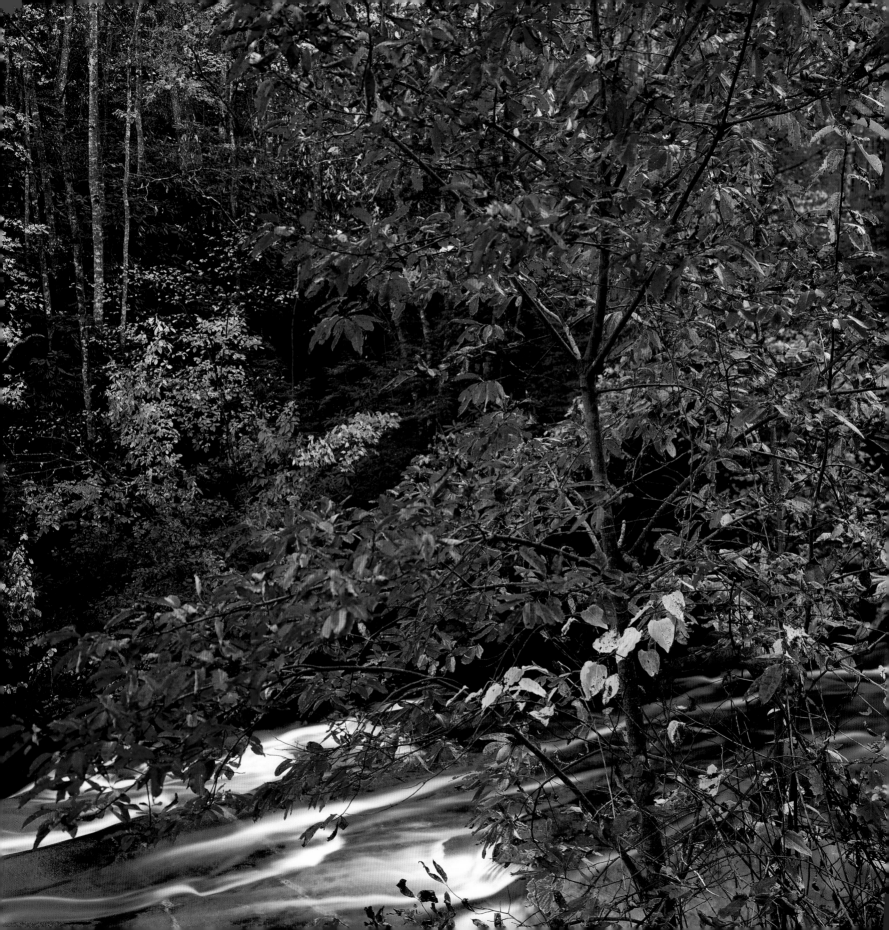

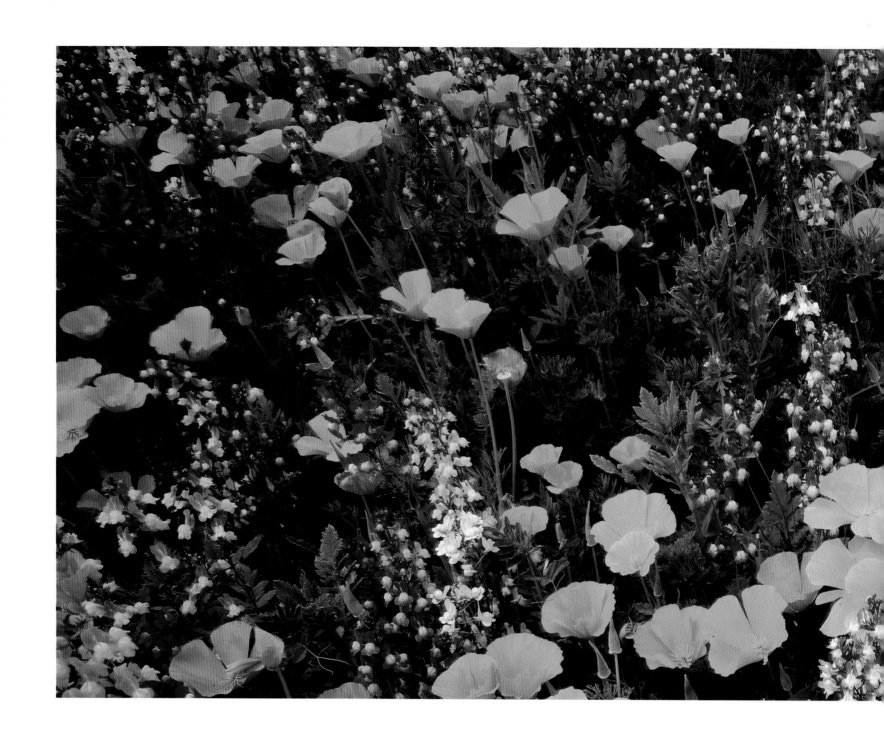

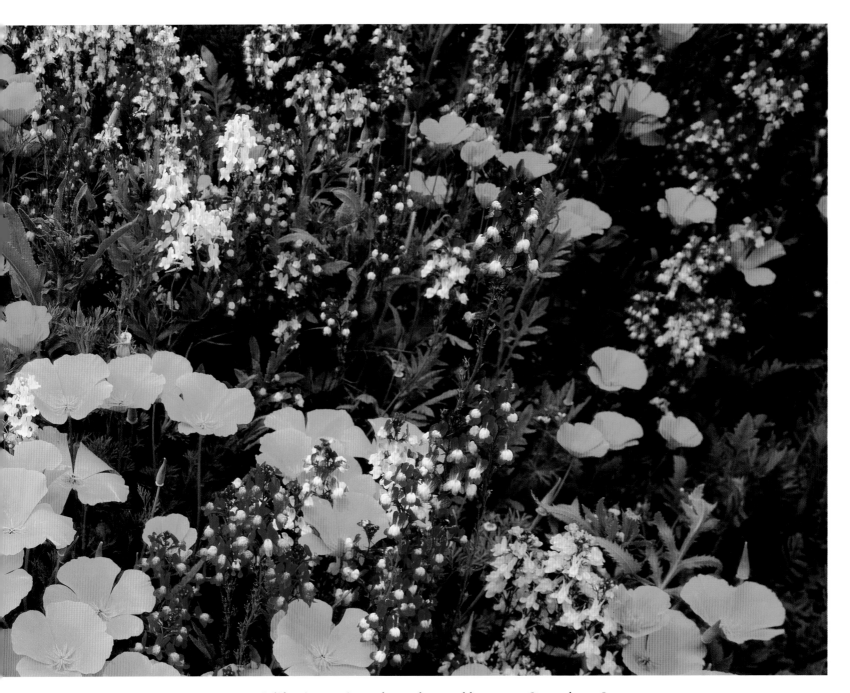

▲ California poppies and snapdragons bloom near Swannsboro. Jean Giraudoux in *The Enchanted* wrote, "The flower is the poetry of reproduction, It is an example of the eternal seductiveness of life."

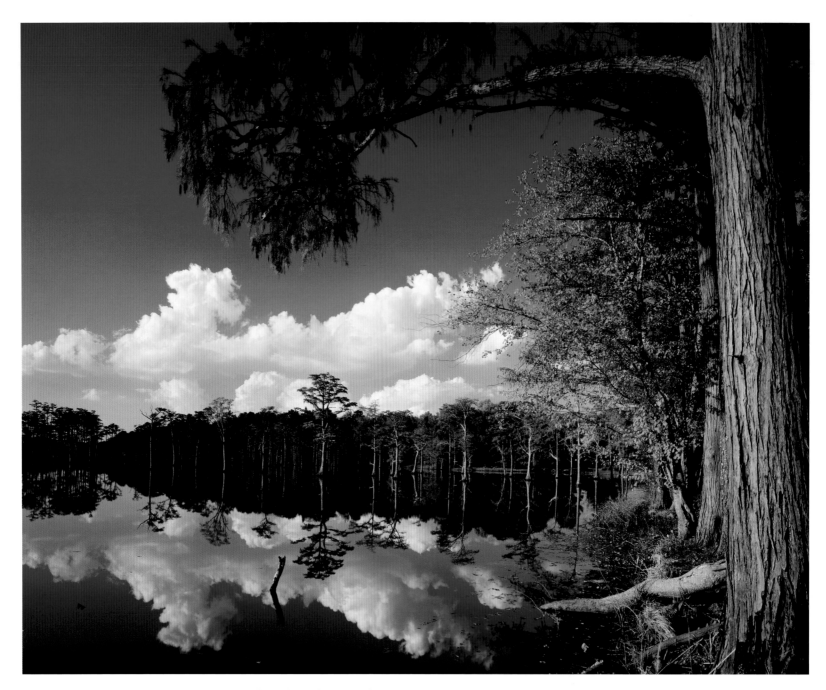

▲ Millponds such as Buie's Pond, situated in Robeson County, were constructed in the 1700s to provide a source of power for watermills.

▶ In temperate rain forests like the Great Smoky Mountains, decomposing forest matter has accumulated over years, creating a rich deposit of earth.

▶ ▶ Cullasaja Falls plunges 250 feet into the lower reaches of Cullasaja Gorge. Cullasaja is a Cherokee word meaning "sugar" or "sweet."

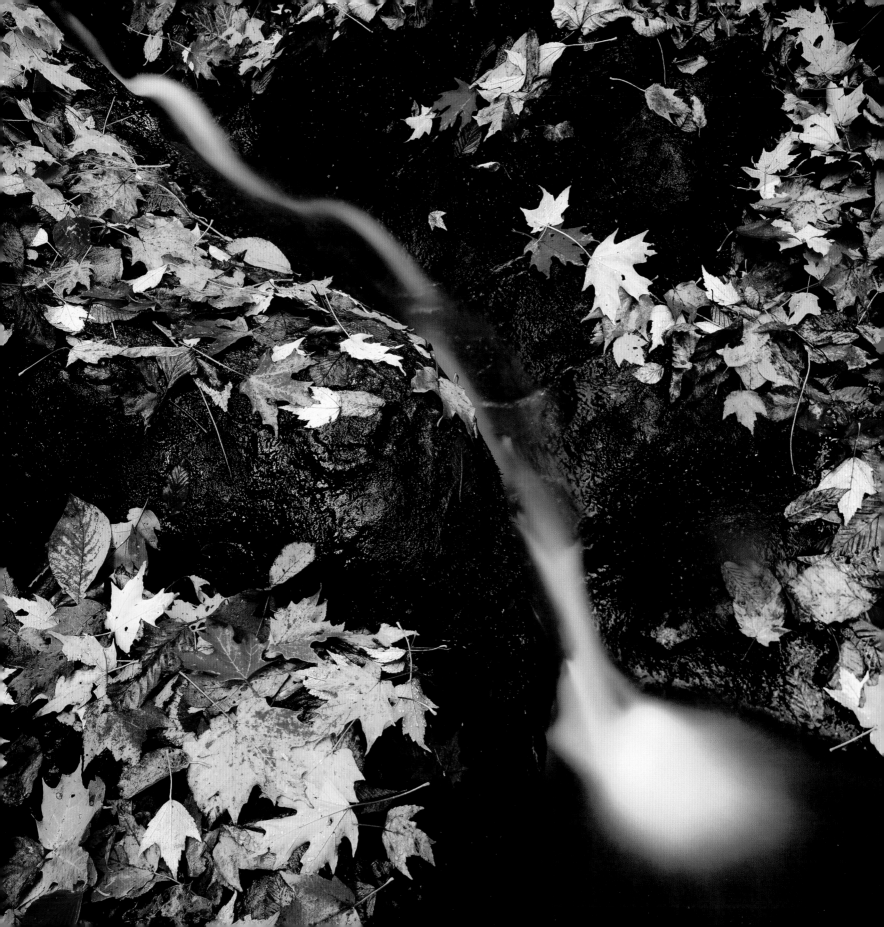

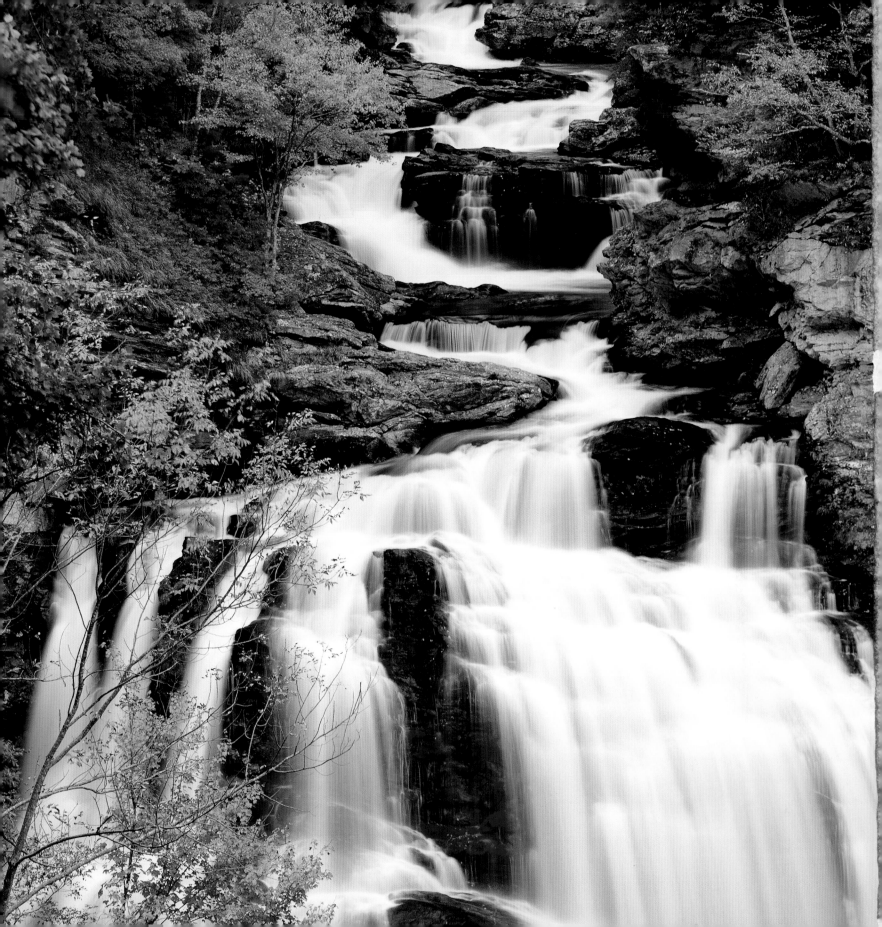